COTTON

*From Southern Fields
to the Memphis Market*

COTTON

From Southern Fields to the Memphis Market

William Bearden

ARCADIA

Copyright © 2005 by William Bearden
ISBN 0-7385-1781-X

Published by Arcadia Publishing
Charleston SC, Chicago IL, Portsmouth NH, San Francisco CA

Printed in Great Britain

Library of Congress Catalog Card Number: 2005920901

For all general information contact Arcadia Publishing at:
Telephone 843-853-2070
Fax 843-853-0044
E-mail sales@arcadiapublishing.com
For customer service and orders:
Toll-Free 1-888-313-2665

Visit us on the internet at http://www.arcadiapublishing.com

CONTENTS

ACKNOWLEDGMENTS

During the compilation of this book, I tried to immerse myself in the cotton culture of the South. In my mind, I traveled back to my childhood years in the Mississippi Delta, remembering the sights and sounds of the field hands going to the cotton fields on early summer mornings and returning late in the afternoon, the rows of sharecropper houses on the plantations, the sounds of tractors and cotton pickers, and the plantation bells tolling the noon hour. These memories and a thousand others came vividly back to me as I searched out photographs and written accounts of life in the Delta. I reread books I had not thought of in 35 or 40 years, most notably William Alexander Percy's *Lanterns on the Levee*, an account of the famous Delta poet/lawyer/planter's life in Greenville, Mississippi, from the turn of the century, through the great flood of 1927, and the beginning of World War II. I also was given a copy of James K. Bettersworth's seminal textbook history of Mississippi, a book I had not opened since high school, and then rarely and most certainly in a frantic state, minutes before a test. Both of these books and many others were interesting on a number of levels. Conventional thought changes, and our perceptions change along with it. Like opening a time capsule, these books offer a window to an era gone by and give deeper meaning to the photographs taken during this time. I gained a better understanding of the plight of African Americans caught in the dreadful cycle of few—if any—social, economic, and educational options and a life filled with the drudgery of working to fulfill someone else's dreams and ambitions. I also came to understand the struggles of the pioneers of the Delta—Leroy Percy, Hugh Foote, Billy Wynn, and thousands of others who settled the Delta, clearing the vast forests, draining swamps, and putting their fortunes on the line in the hopes of making it in this unforgiving land. For these insights, I thank the authors and many other friends and associates who informed and influenced my thinking in one way or another.

Another key to my understanding of the cotton business came from Memphis cotton man Calvin Turley. Calvin's knowledge regarding the complicated world of cotton trading, as well as his deep respect and appreciation for the generations who came before him on Memphis's Front Street, have been valuable, insightful, and thoroughly entertaining. The written history of the Cotton Exchange by Janie V. Paine was especially helpful in establishing a timeline and understanding the complexities of the cotton trade. I am deeply grateful to my daughter and co-editor, Savannah Bearden. We have worked closely on the writing and layout of this book, a process that has led me to appreciate her even more.

Much of the joy of my work is that of a visual archaeologist, unearthing images from sometimes unlikely places. Part of the frustration of working for months on a book project or a

documentary film is the inevitable "day after" syndrome. No matter how many thousands of photographs have been researched, begged, or borrowed, no matter how much footage has been filmed or how many people interviewed, the day after a book publication or a documentary premier, the phone rings and someone has the perfect photograph or historical film clip. The problem lies in the fact that once it's done, it's done. At that point, there is no going back to add pages or scenes, and no more soliciting stories or dim memories. That finality is liberating, but at the same time, I wish I could know for sure that I had seen everything. The fact remains that we will never know all the names or faces of the true authors of this story. So at this point, I must say, "I've seen everything. It is done."

I want to thank the following individuals and institutions for the use of the images that appear in this book: Ed Frank of Special Collections at the University of Memphis has been especially helpful in searching his collection for rare and interesting items; the Abe Frank Collection at Special Collections at the University of Memphis; my friend Jim Johnson at the Memphis Room of the Memphis/Shelby County Public Library and Information Service; Dr. Douglas Cupples, professor of history at the University of Memphis; Ed Galfsky and the Carnival Memphis staff; the Library of Congress, Prints and Photographs Division, National Child Labor Committee Collection, Lewis Hine Photographs; the Library of Congress, Prints and Photographs Division, FSA/OWI Collection; and the National Cotton Council. I wish to thank the many unknown photographers who thought it important to capture many of the images that appear in this book.

A special note of thanks goes to my editor, Adam Latham, at Arcadia Publishing. His insight, resourcefulness, and enthusiasm were essential to this project.

I want to thank the following people for their help in pushing this project along, through a conversation or a piece of advice or for simply encouraging me in my many endeavors: Dudley Davis; Marjorie "Miss Andrews" Hogben; Jay Martin; Fran Catmur; Lori Finta; Sid Selvidge; John, Vanessa, and Olivia Greenham; George Quarm; Clark Secoy; Michelle Secoy; Joey Waldon; Charles Weissinger; Anne Wynn Weissinger; Ben Lamensdorf; Mike Lamensdorf; Laurence Carter; Ray Mosby; Natalie Perkins; Nancy Virden; Lynn Moses; Wiley Price; Henry Hunter; Gordon and Sue Quarm; Arthur Bell; Frank Mitchener Jr.; Calvin Turley; Danny Lyons; Robin Salant; Greg Newby; Scott Blake; Robert Dye; Bill Robison; Blaine Baggett; Tom Harris; Tia Hall; Carolyn Hawkins; Tricia May; Steve and Teresa Williams; Louis Pounders; David Williams; Suzanne Hopper; Jerry Martin; Bill Rutherford; Ricky Lee; Isaac Stamps; Patricia La Pointe; Howard and Baylor Stovall; Stan Johnson; William Lee Dees; Adam Latham; Rafe Murray; Elton Robinson; Barry Burns; Chuck's in Rolling Fork, Mississippi; The Gray Hounds; David Durrett; Robert Beaver; Keith Carmack; Robert Waldon; Jerry Lambert; Bub Branton; my mother, Virginia Trigleth; my second mom, Dot Helton; Frances Johnson; Debbie Walker; Eugene Trigleth; Jeff Bearden; Gaines Bearden; my children, Savannah, Matt, and Maggie; and my wife and best friend, Cheryl.

INTRODUCTION

In the barbecue joints and plate-lunch cafes off Memphis's Front Street, a mostly hidden society exists. The view into this world is slightly opaque to all but those in the know, but in its glory days, it wielded a measure of influence that is unheard of in today's world. It was a society peopled with characters and cads, the big and the small time, the rich and the richer, the hangers-on, the anointed, the powerful, and the busted. It created empires in agriculture, transportation, banking, warehousing, and a hundred other businesses throughout the South and around the world. And even though much of the day-to-day dealings have moved to manicured office parks, high-rise office buildings, and other non-descript locales, its influence remains at the core of the Memphis economy and Memphis society. It was the determining factor in a way of life that enslaved generations of human beings. It spawned a war that pitted brother against brother and nearly destroyed the United States in the process. It propelled technological advances that changed the face and the soul of the South. It was the wellspring from which modern music and much of our popular culture came into being. It triggered migrations by millions of blacks and poor whites, changing forever the culture of northern cities like Chicago, Detroit, and St. Louis. Its allure has called out to writers, artists, photographers, and other cultural chroniclers from around the world, drawing the curious to plumb the depths of its strength and energy. It spawned its own literature in the writings of William Faulkner, Walker Percy, Shelby Foote, Richard Wright, Willie Morris, and dozens of others. Its influence is the nucleus of what popular music, through blues and jazz and rock-and-roll, has become. This all-powerful entity is cotton.

No one came to the Delta for any reason other than cotton. The Jewish immigrants who ran dry-goods stores that were huddled around tiny town squares, Chinese grocers, Italian laborers, Syrian shopkeepers, and African-American sharecroppers—who outnumbered whites ten-to-one in some counties—were here for one reason and one reason only: the white gold that grew better in the rich Delta topsoil than anywhere else on earth.

Cotton iconography is ubiquitous throughout the Deep South. A look in any phone book will give listings for Cotton Boll Catering, Cotton States Warehouse, Cotton Land Motel, and on and on. It is part of our heritage, but it is disappearing as modern life pushes the cotton business and its symbols further and further from the public eye.

I was in the south Delta in the fall of 2004, photographing the cotton harvest, when I stopped by Delta planter Ben Lamensdorf's office in the tiny hamlet of Cary, Mississippi. The annual harvest was in full swing; the long October days had been dry and sunny, perfect for picking cotton. The air-conditioner hummed like a ubiquitous Delta mantra in the hot afternoon, a

welcome respite from the 95+ degrees of the outside world. After the usual pleasantries, our conversation drifted deftly to the harvest at hand and then moved, unsurprisingly, to the importance of cotton to the Delta. Ben asked rhetorically why my own father had come to the Delta in 1939, why Jewish immigrants made the trek to this sometimes inhospitable and unknown land, why throngs of Chinese, Italian, and Syrian settlers came to the Delta at the beginning of the 20th century, and why, even today, Mexican and Central American immigrants flock to this crescent-shaped parcel of land that has scarcely been settled for 100 years. The answer, again, is cotton.

The Lamensdorfs' far-flung operation included a new six-row John Deere cotton picker that could fly down the rows at an amazing four miles an hour, necessitating a stop about every 10 minutes or so to unload the hundreds of pounds of cotton in the giant basket—a far cry from the tentative move to cotton-picking mechanization some 50 years ago. In those days, it would have taken dozens of people dragging 10-foot-long cotton sacks and picking at a furious pace, from sunup to sundown—or in local parlance, "from can to can't"—to equal an hour's yield of the gleaming John Deere, with its air-conditioned cab and cutting-edge technology. Driver Isaac Stamps lined it up on the row, and the picker did the rest, feeling its way precisely through the sea of white, down rows profuse with the white gold of the Delta.

The next day, with old friend and Delta planter and attorney Charles Weissinger, I followed the process of getting the cotton from the field through the gin. Like industrious bees, the well-coordinated support machines dashed to and fro in the field, pulling "boll buggies" from the picker to the module-making machine that compresses the freshly picked cotton into giant white loaves. These modules are scattered throughout the fields awaiting the trip to the gin, where the serious business of separating the cotton lint from the seeds takes place. I was amazed at the efficiency of the operation, and I found it fascinating that this technology was the direct progeny of Eli Whitney's simple invention more than 200 years ago.

Also in the Delta that day were fast, powerful airplanes, flying mere inches across the tops of the cotton plants. They banked perilously over the too-near tree line before lining up again for another pass along the length of the rows, spraying a defoliant chemical to rid the mature plants of their leaves, all in preparation for the imminent approach of the cotton picker. This scene plays out every fall across the South from the Carolinas to Texas and beyond. The business of cotton is a fine art, an intricate combination of technological innovations, business stratagem, decades-old experience, fear, and simple, unadulterated luck.

On that same October day, cotton merchant Calvin Turley, working from his second floor office in the Memphis Cotton Exchange building overlooking historic Cotton Row, sold 500 bales of Memphis-territory cotton to a mill in India, completing the round-the-globe sale by email and fax. This is a far cry from the telegraph communications or registered letters of earlier times. The cotton would be taken from a warehouse in Greenwood, Mississippi, loaded into a container, drayed to Memphis, shipped by railcar to the port of Los Angeles, loaded onto an giant oceangoing container ship for its 8,000-mile journey to Tuticorin, India, taken by truck to a mill in Madras, and woven into cloth that will ultimately become bed sheets, tablecloths, t-shirts, or the thousand other items we commonly use . . . all made from cotton. These circuitous market pathways have been constructed, refined, and nurtured by generations of farmers, merchants, and cotton men from around the globe, culminating in an intricate symphony performed with an exacting degree of skill on virtually every day of the year. The cotton business is big business.

My experience on that October day was by no means unique. In cities, small towns, and rural settings across the South and West, on farms in Pakistan, India, Egypt, and across South America and Asia, similar scenes are played out, as the business of cotton moves forward at its own undeniable pace. In all of these activities, there exists an unbroken connection to the past—a tie to the land that is deeper than words can describe. The modern cotton farmer frets no less about the weather, prices, and labor than did his counterpart in 19th-century Natchez, Mississippi. As much as things have changed, they have stayed fundamentally the same.

My connection to the world of cotton began long before I was born. My great-grandfather owned Woodland Plantation near Port Gibson, Mississippi, at the turn of the century. When I was a child, my family lived not 100 yards from the cotton compress in Rolling Fork, Mississippi. The familiar whooshing sound of the giant steam-powered press inhabited my days and nights, its comforting rhythm always there as laborers unloaded the seemingly never-ending railroad boxcars filled with cotton to be pressed into uniform bales and stored in the enormous warehouse. It was the largest building in our town. My first job was chopping cotton on the Mound Plantation for $3 a day. And after jobs ranging from toting water in the fields, to driving a tractor, to measuring cotton, I still find beauty in the landscape of the Delta, and I find myself looking out across the fields as if they were my own.

One
COTTON COMES
TO THE COLONIES

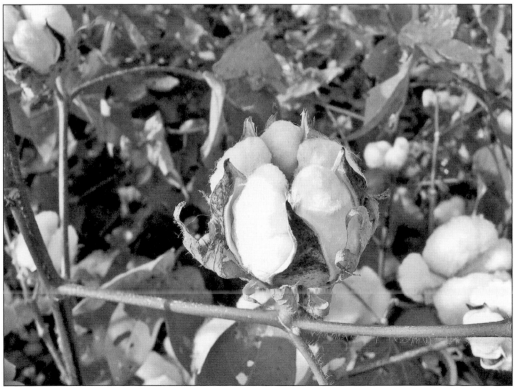

This mature cotton boll symbolizes much—the expectations of the farmer who grew it, the merchant who will sell it, and the substantial weight of its own history as one of the most important plants in the history of mankind.

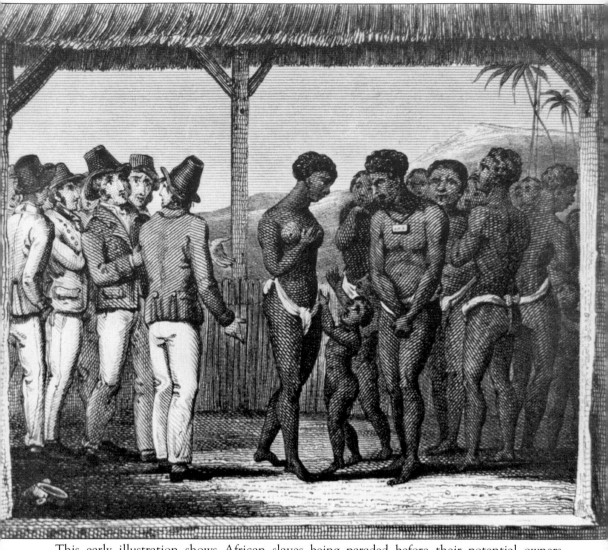

This early illustration shows African slaves being paraded before their potential owners. Enslaved Africans represented many different peoples, each with distinct cultures, religions, and languages. Most originated from the coast or interior of West Africa. The demands of European consumers for New World crops helped fuel the slave trade.

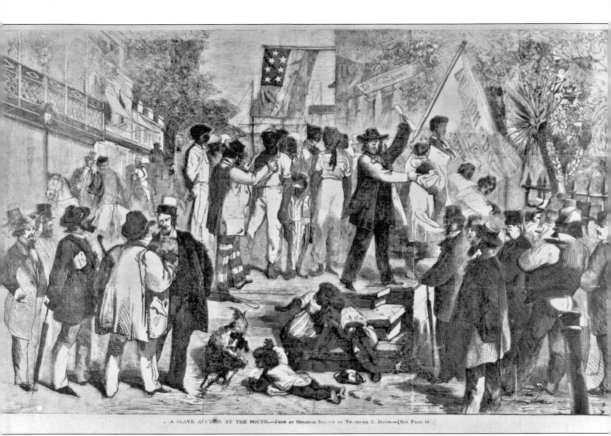

A SLAVE AUCTION AT THE SOUTH.—From an Original Sketch by Theodore R. Davis.—[See Page 44.]

By 1860, some four million enslaved African Americans lived throughout the South. Most were agricultural workers who toiled from sunrise to sunset, while others held specialized jobs as artisans or skilled laborers. A strong family and community life helped sustain African Americans in slavery.

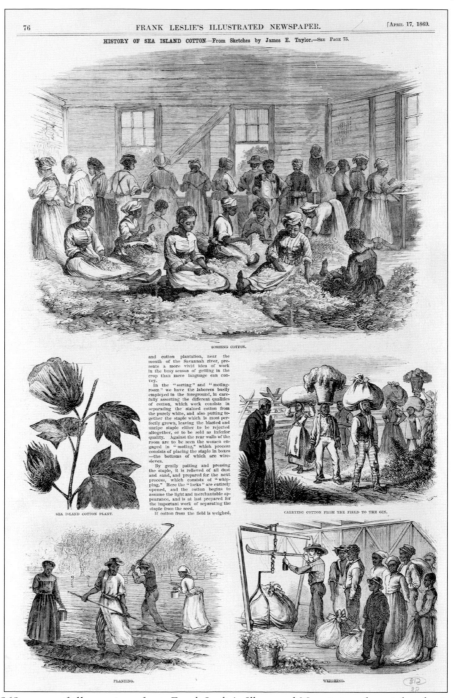

An 1869 group of illustrations from *Frank Leslie's Illustrated Newspaper* chronicles the journey of cotton from the fields of Sea Island, Georgia, to the mill.

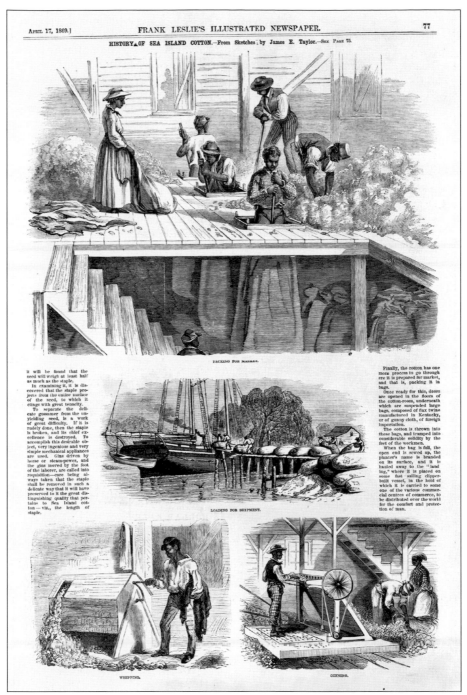

HISTORY OF SEA ISLAND COTTON.—From Sketches by James E. Taylor.—SEE PAGE 75.

PACKING FOR MARKET.

LOADING FOR SHIPMENT.

WHIPPING.

GINNING.

In the early days of the cotton industry, all work was done by hand. This labor-intensive work pushed the development of technological innovations that continues today. This quote from *Frank Leslie's Illustrated Newspaper* aptly describes the process of separating cotton from the seed. "It is discovered that the staple projects from the entire surface of the seed to which it clings with great tenacity. To separate the delicate gossamer from the unyielding seed is a work of great difficulty."

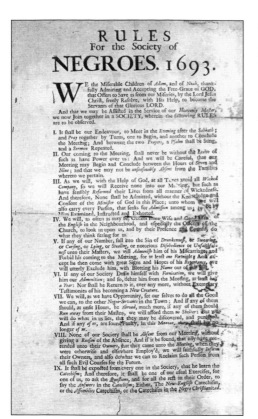

This 1693 document outlines accepted practices and behavior for members of the Society of Negroes. Theirs was a commitment to the teachings of Jesus Christ. Throughout the 18th and 19th centuries, African Americans increasingly adopted the religions of their owners, but they often mixed beliefs passed down from their African forebears, creating a hybrid of Christian and Animist practices.

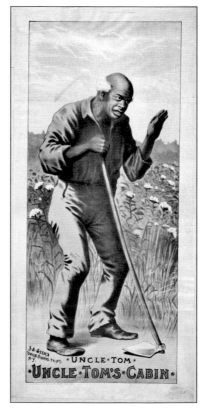

These words, written by Harriet Beecher Stowe in an introduction to *Uncle Tom's Cabin* in 1852, were to ring out as a most effective denunciation of slavery and helped to change public perception. "The great mystery which all Christian nations hold in common the union of God with man thro' the humanity of Jesus Christ invests human existence with an awful sacredness and in the eyes of the true believer in Jesus, he who tramples on the rights of his meanest fellow-man, is not only inhuman but sacrilegious—and the worst form of this sacrilege is the institution of slavery."

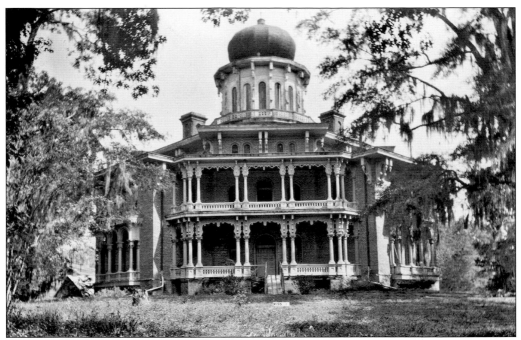

Longwood, more commonly known as "Nutt's Folly," was built around 1860 by Dr. Haller Nutt in Adams County, Mississippi, near Natchez. The bricks were handmade by slaves on the premises, and the wood used on the columns and the elaborate exterior was sent to Philadelphia, Pennsylvania, to be hand carved. Due to the outbreak of the Civil War, work was halted in 1861, and the octagon-shaped house was never finished.

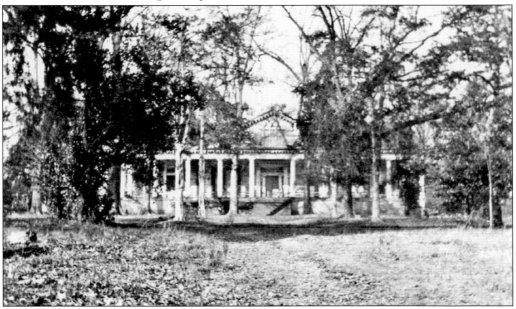

This *c.* 1920 photograph depicts Woodland Plantation outside of Port Gibson, Mississippi, the town Gen. Ulysses S. Grant deemed "too beautiful to burn" during the Civil War. Woodland was built in the 1880s and was the home of the author's great-grandparents, Mathew Gaines Bearden and Albina Cooper Bearden. The home burned in 1935.

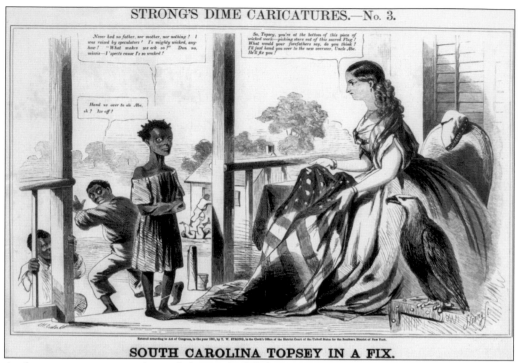

SOUTH CAROLINA TOPSEY IN A FIX.

As her mistress accuses her of the wicked behavior of picking stars off the flag, Topsey speculates that her behavior is the result of her raising by speculators. These types of caricatures helped to crystallize the anti-slavery feelings of many in the North. A storm was brewing.

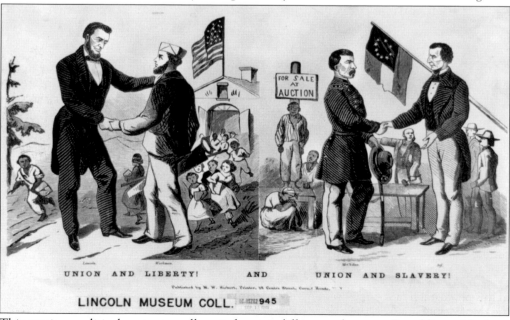

UNION AND LIBERTY! AND UNION AND SLAVERY!

This partisan political cartoon spells out the vast differences between Republican Abraham Lincoln and Democratic challenger George McClellan in the presidential race of 1864. Here, McClellan is seen shaking the hand of Confederate president Jefferson Davis, while Lincoln greets the American workingman. Although not expected to, Lincoln won a second term.

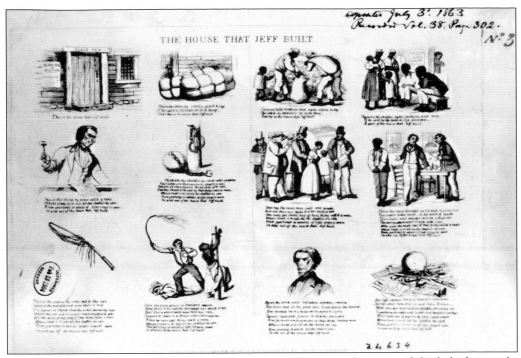

"The House that Jeff Built" was published in July 1863 as an indictment of the beliefs, morals, and aspirations of Confederate president Jefferson Davis. After the end of the Civil War, Davis was arrested and imprisoned for two years at Fortress Monroe in Virginia.

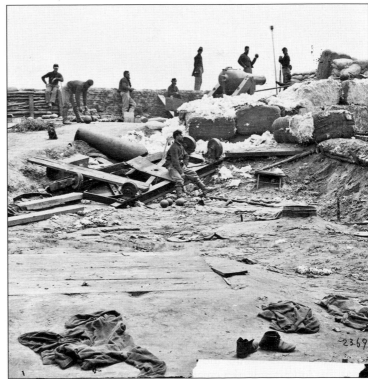

Like Gen. Andrew Jackson in the War of 1812, soldiers use cotton bales for breastworks against the opposing Union forces in this photograph of the Confederate fortifications during the Peninsular Campaign of May–August 1862, near Yorktown, Virginia.

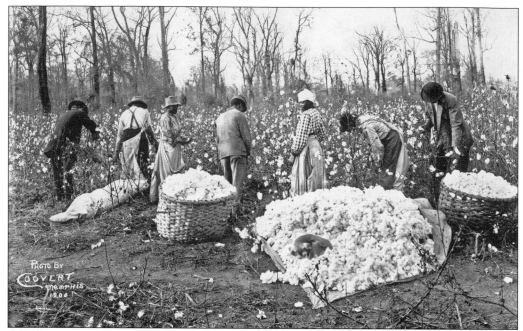

After the end of the Civil War and slavery, many African Americans moved north in the hope of finding new opportunities and a friendlier social climate. However, many ex-slaves stayed in the South, doing what they knew: farming cotton, but this time as sharecroppers, not slaves.

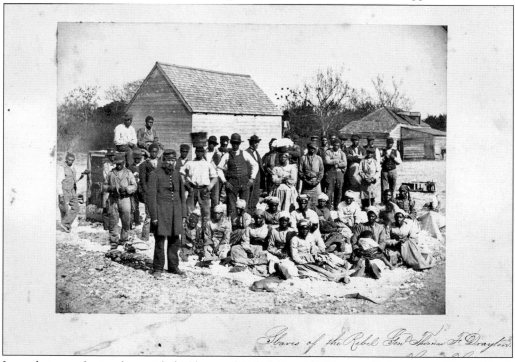

In a photograph simply entitled "Slaves of Rebel General Thomas F. Drayton, Hilton Head, S.C.," we see what appears to be a Union officer standing with the slaves. This photograph was perhaps taken when Union forces overran Hilton Head.

Ex-slaves pose at a cotton warehouse in Charleston, South Carolina. The Civil War had devastated much of the agricultural infrastructure of the South. Warehouses, gins, barns, plantations, and tenant homes had to be rebuilt. Cotton was still in great demand, and the South answered by quickly getting back to the business of farming.

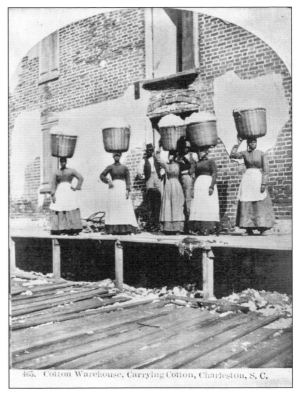

465. Cotton Warehouse, Carrying Cotton, Charleston, S. C.

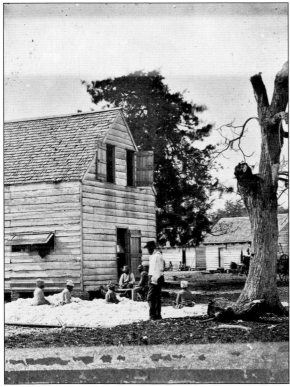

Much of the work of cotton was still done by hand after the Civil War. Here, workers pick the lint from the cotton seed by hand in a painstaking and time-consuming process.

21

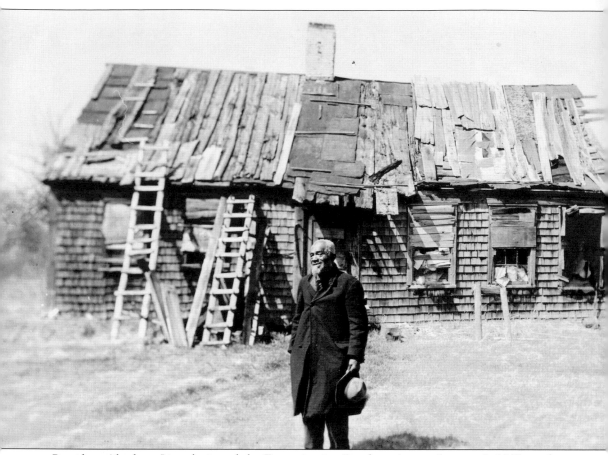

President Abraham Lincoln issued the Emancipation Proclamation on January 1, 1863, as the nation approached its third year of bloody civil war. The proclamation declared, "that all persons held as slaves" within the rebellious states "are, and henceforward shall be free." Juneteenth, or June 19, 1865, is considered the date when the last slaves in America were freed. Although the rumors of freedom were widespread prior to this, actual emancipation did not come until Gen. Gordon Granger rode into Galveston, Texas, and issued General Order No. 3 on June 19, almost two and a half years after Lincoln signed the proclamation.

Two

THE RISE
OF TECHNOLOGY

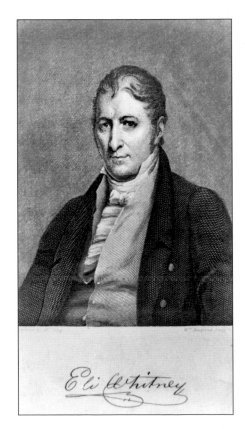

In 1793, 28-year-old Eli Whitney watched the
cotton cleaning procedure and carefully examined
the hand movements. One hand held the seed
while the other hand pulled out the short strands
of fiber covering it. The machine he ultimately
designed simply copied these hand motions . . .
and changed the world.

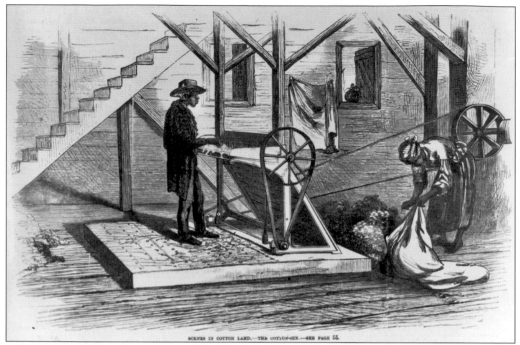

The amount of raw cotton grown in the United Stated doubled each decade after 1800 as a result of the cotton gin. Demand was stimulated by other important inventions of the Industrial Revolution, such as the machines to spin and weave it and the steamboat and steam locomotive to transport it.

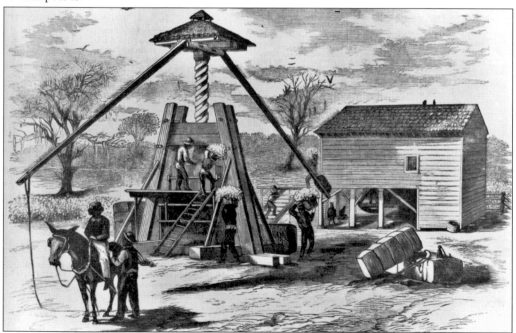

By 1850, America was responsible for three-quarters of the world's supply of cotton. Most of the crop was shipped to England or New England where it was manufactured into cloth. At mid-century, the South produced about two-thirds of America's exports—most of it in cotton.

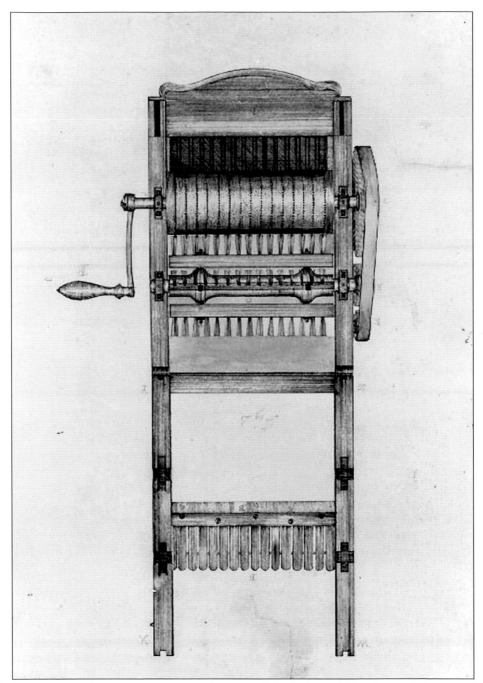

The invention of the cotton gin was at the core of the Industrial Revolution. The gin, whose name was shortened from "engine," approximated the work of human hands pulling cotton from the surface of the small cotton seeds. This process involved the seed being held in place by a system of fine parallel wires, much like a comb. A drum, covered with small hooks, rotated past the wires, pulling the lint from the seed. A rotating brush then pulled the fibers off the hooks and away from the drum, producing pounds of cleaned cotton in a mere fraction of the time it had previously taken.

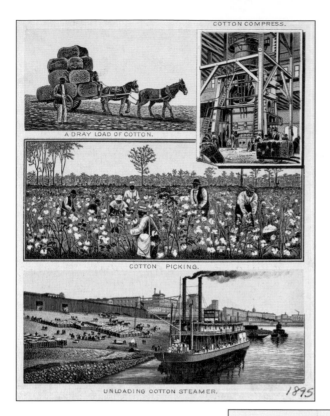

COTTON COMPRESS.

A DRAY LOAD OF COTTON.

COTTON PICKING.

UNLOADING COTTON STEAMER.

1895

Technology, pushed along by the cotton economy, yielded new innovations each year, as cotton truly became "King in the South." Steamboats plied waterways small and large, bringing cotton to the Memphis market.

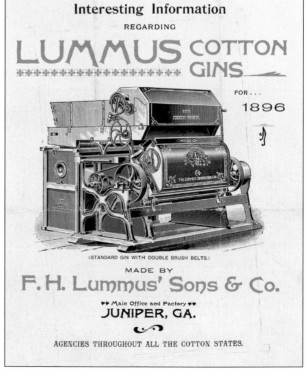

Interesting Information
REGARDING

LUMMUS COTTON GINS

FOR...
1896

(STANDARD GIN WITH DOUBLE BRUSH BELTS.)

MADE BY
F. H. Lummus' Sons & Co.

♥♥ Main Office and Factory ♥♥
JUNIPER, GA.

AGENCIES THROUGHOUT ALL THE COTTON STATES.

The manufacture of farm and gin equipment became big business, as cotton farming spread across the South. Gins became faster and faster, making the time between the harvest and shipment to mills shorter still.

Out in the cotton field with nothing but a hoe, this farmer has his work cut out for him. Although cultivators, plows, and tractors were becoming available, many farmers still worked with the tools of the past.

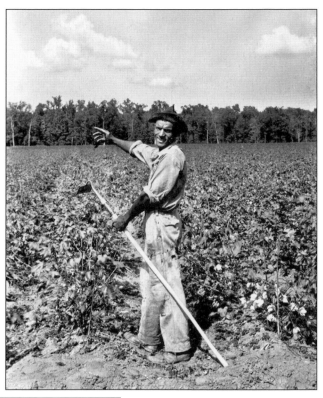

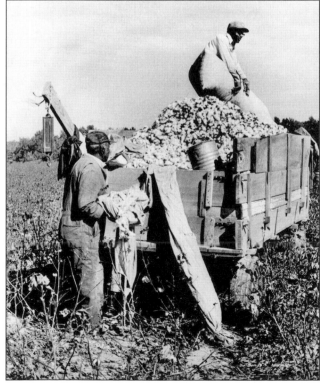

Old cotton wagons eventually gave way to bigger trailers. In this c. 1940 photograph, William "Shine" Palmer and Charlie Jefferson weigh their cotton and pack it in the wooden wagon for the trip to the gin.

27

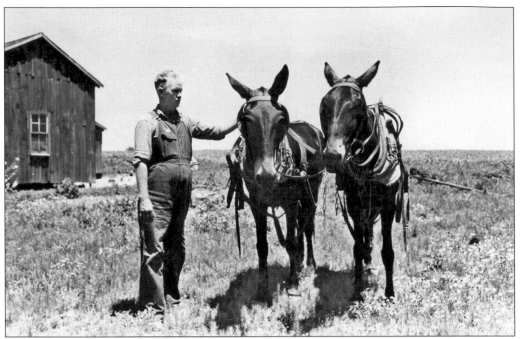

The South ran on animal power before the advent of the internal combustion engine. Horses and oxen were bought and sold throughout the region, but the mule was the prized possession of Southern farmers. Mississippi author William Faulkner opined, "A mule will labor 10 years willingly and patiently for you, for the privilege of kicking you once."

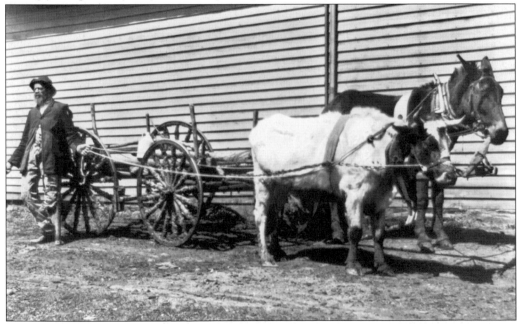

This mixed team of horse and ox was a common sight throughout the South. Although rarely seen today, oxen were strong, patient, and hardy. They could live on rough foods without much shelter, but generally they were quite slow. Only a few could walk and draw a plow along with the horses, and on the road, an ox team did well to make three miles an hour.

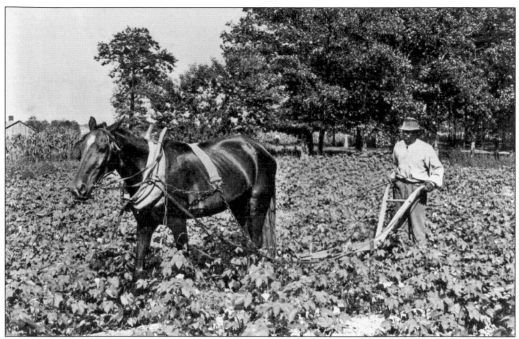

A man and his mule pass a long afternoon out in the cotton patch. When asked how he made his rows so straight, an old farmer replied, "You pick out an object at the opposite end of the field from where you start, such as a tree or fence post, line it up between your mules ears and go straight to it."

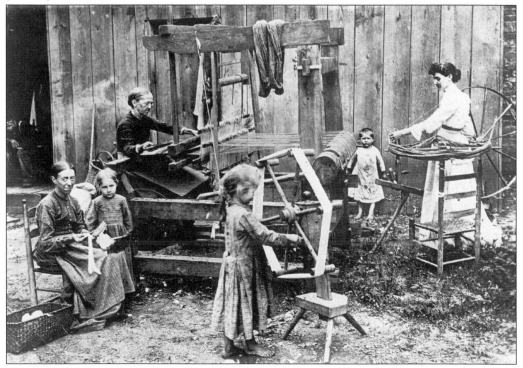

Spinning cotton into thread and finally into cloth was a slow process that took many hands.

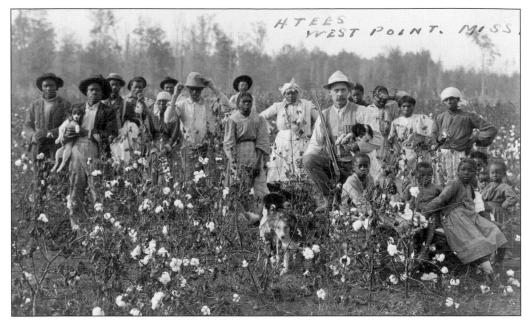

This plantation owner, attired for dove hunting, wears his hunting vest and shotgun as he poses with his workers in this turn-of-the-century photograph. Cotton-picking time was the culmination of the year's efforts, so everyone was expected to help out in the fields.

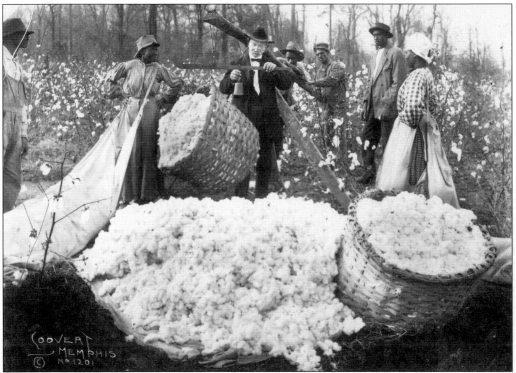

The plantation overseer weighs the cotton at the end of the day. Laborers used 10-foot-long cotton sacks to pick through the field, and they then loaded the cotton into split-wood baskets to be weighed. A fast man or woman could pick up to 300 pounds in a day.

This early tractor pulls a human-guided plow. The steel wheels were thought to have better traction in the sometimes muddy fields. It is not known why these men are wearing suits and ties to work in the field.

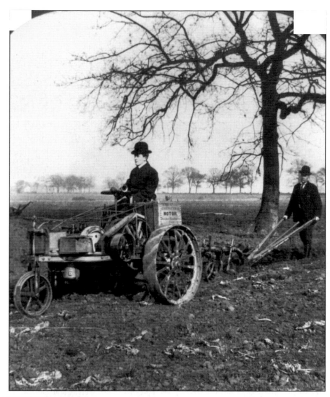

The International Harvester Company was formed by the merger of the McCormick Harvesting Machine Company and the Deering Harvester Company in 1902. The company had a number of early tractor models. The Farmall introduced the tricycle style row-crop tractor. It could not only plow but was capable of precision work such as cultivating. Shown here is Fulton, Mississippi farmer Tom Harmon. The tractor, which Harmon affectionately called "the cub," revolutionized his method of farming and made it possible to grow more crops on his small farm. (Courtesy Frances Johnson.)

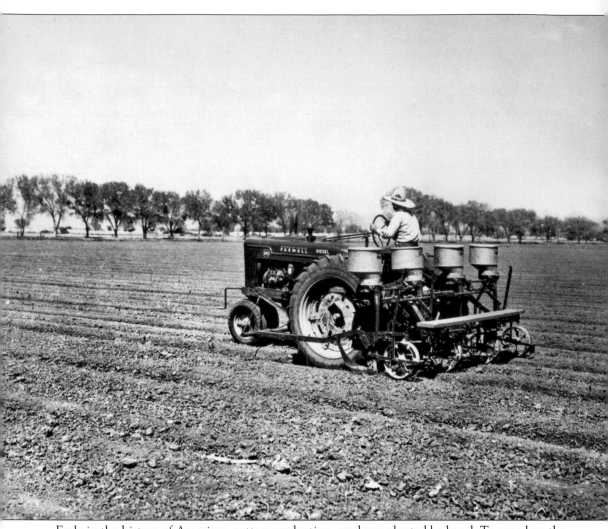

Early in the history of American cotton production, seed was planted by hand. To speed up the process, crude planters who dropped the seed unevenly were attached to the horse-drawn plow. With the advent of motor-driven tractors, vast improvements were made possible in planting equipment. Pictured is a tractor-drawn machine that plants seed in four rows at once. Distribution of seed is even throughout the length of the row, assuring a uniform stand of cotton plants. Like other mechanized devices, the four-row planter was a great saver of time and labor.

The system of sharecropping was developed after the Civil War, when landowners had land but no money. Former slaves had labor but no land, so a deal was struck: a year's labor for a percentage of the profits. Although flawed, and many times unfair to the tenant, the system lasted until the 1960s.

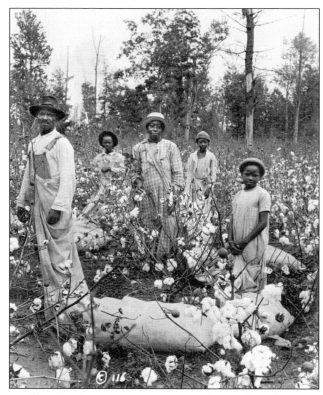

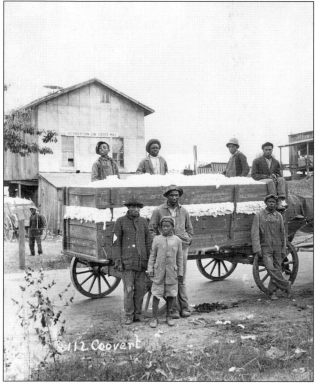

Most sharecroppers were somewhat isolated on big plantations, rarely getting into town. In the fall, the cotton gin became a gathering place where gossip was exchanged, old friendships renewed, and local news passed along.

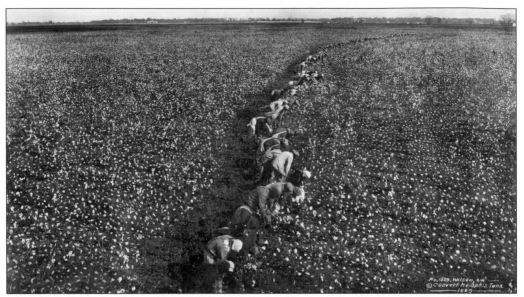

In a photograph that appears almost unbelievable, dozens—possibly hundreds—of laborers fan out across this Arkansas cotton field to make short work of the harvest.

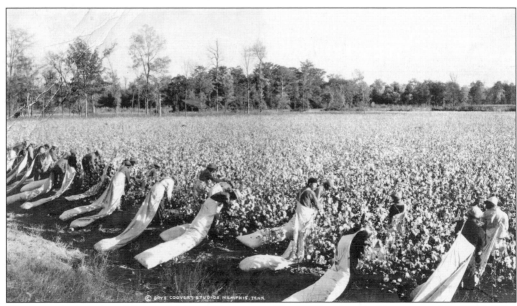

Cotton prices dropped from a high of 35¢ a pound in 1919 to barely 11¢ a pound in 1935. The Great Depression sent many farmers into bankruptcy and many African Americans to northern cities such as Chicago and Detroit.

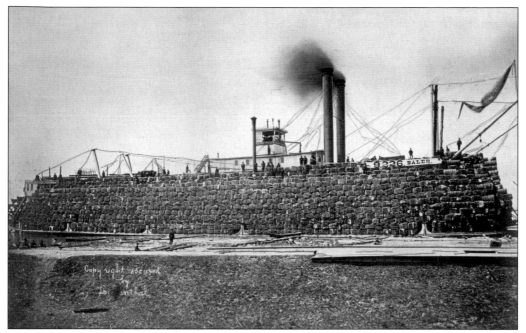

This 1889 photograph shows a steamboat packed to the top with bales of cotton. The steamboat business was booming in the years after the Civil War, because of good cotton prices and the Mississippi Delta opening to farming.

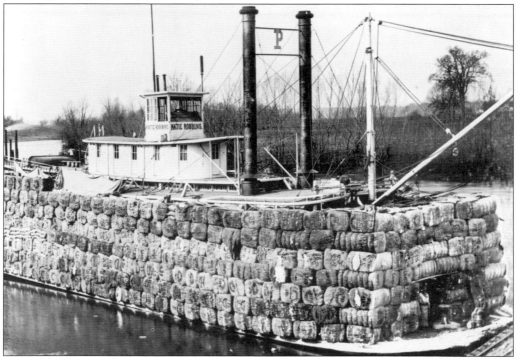

By the turn of the 20th, century steamboat lines were losing much of their freight business to the railroads. The first bridge across the Mississippi River at Memphis opened in 1892, after a valiant fight waged by the steamboat companies.

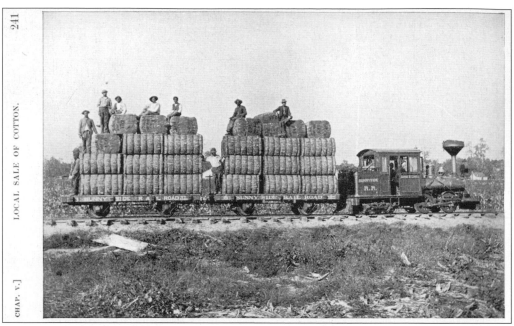

Many large cotton farmers built small railroads to connect their plantation gins and warehouses to the main rail line. This narrow-gauge railroad train was built and owned by the Sunnyside Plantation in Arkansas, just across the Mississippi River from Greenville.

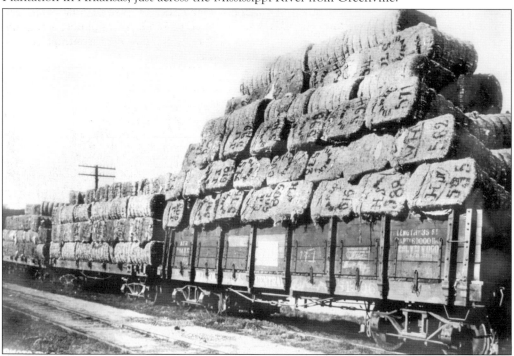

This 1906 photograph shows part of the largest trainload of cotton to come into Memphis from the Mississippi Delta via the Illinois Central Railroad. By the 1970s, in response to increasing competition from trucking companies, the Illinois Central had pulled up its tracks in much of the Delta.

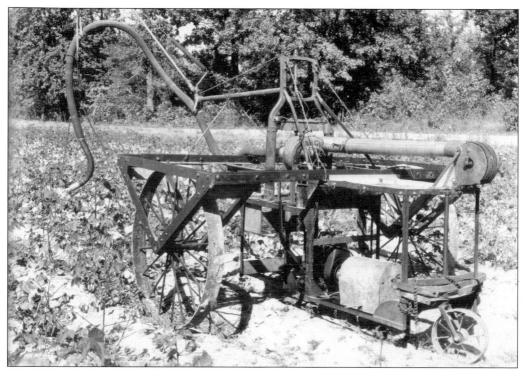

Jedediah Prescott and Samuel S. Rembert of Memphis, Tennessee, received the first patent for a mechanical cotton harvester from the U.S. Patent Office in 1850. It was almost a century before a workable mechanical picker was commercially produced. This early contraption was only one of hundreds of prototypes for cotton-picking machines.

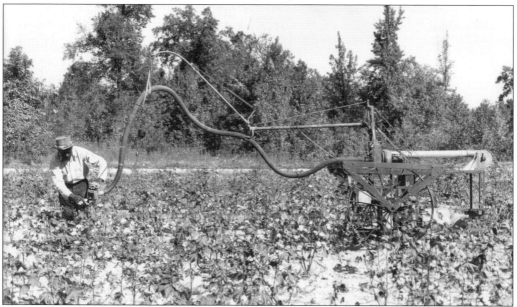

Inventors tried a variety of methods to pick cotton mechanically. Pneumatic harvesters removed lint from the bolls by using suction or a blast of air. Electrical cotton harvesters used a statically charged belt or finger to remove the fiber from the boll.

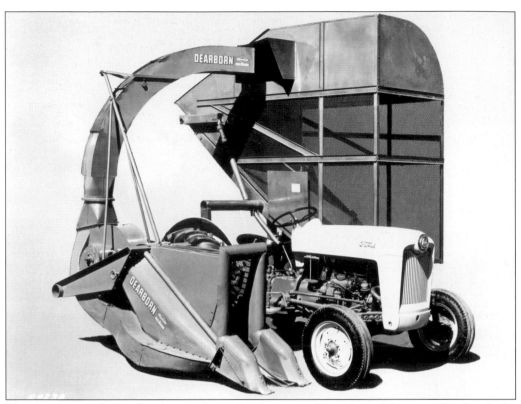

The thresher mechanical picker cut down the plant near the surface of the ground and took the entire plant into the machine, where the cotton fiber was separated from the stalk and leaf material. The stripper harvester combed the plant with teeth or drew it between fixed openings or teeth. The spindle-type machine was designed to pick the open cotton from the bolls using barb-covered spindles, without injuring the plant's foliage and unopened bolls.

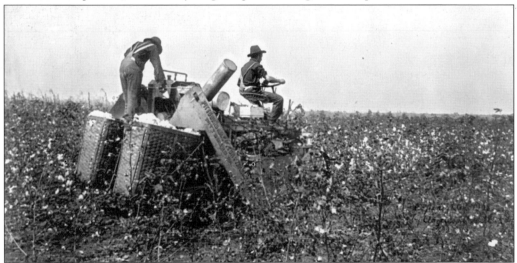

By the mid-1930s, more than 800 patents had been issued on various devices designed to mechanize the harvest of cotton. Dozens of patents covering many types of power-driven cotton pickers followed.

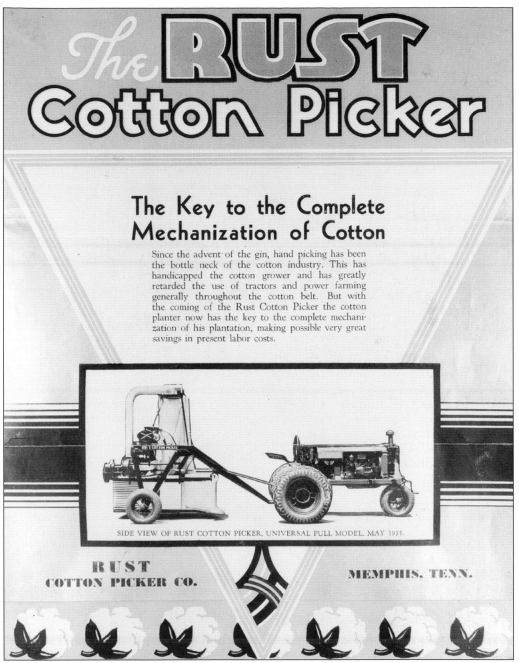

The RUST Cotton Picker

The Key to the Complete Mechanization of Cotton

Since the advent of the gin, hand picking has been the bottle neck of the cotton industry. This has handicapped the cotton grower and has greatly retarded the use of tractors and power farming generally throughout the cotton belt. But with the coming of the Rust Cotton Picker the cotton planter now has the key to the complete mechanization of his plantation, making possible very great savings in present labor costs.

SIDE VIEW OF RUST COTTON PICKER, UNIVERSAL PULL MODEL, MAY 1935.

RUST
COTTON PICKER CO.

MEMPHIS, TENN.

The Rust brothers, John and Mack, are ultimately credited with the invention of the mechanical cotton picker. A 1936 demonstration at the Delta Experiment Station near Leland, Mississippi, sent a shudder through the region. The Rust brothers' machine provoked the fear that a mechanical picker would destroy the South's sharecropping system and, during the Great Depression, throw millions of people out of work. The *Jackson (Miss.) Daily News* editorialized that the Rust machine "should be driven right out of the cotton fields and *sunk into the Mississippi River*."

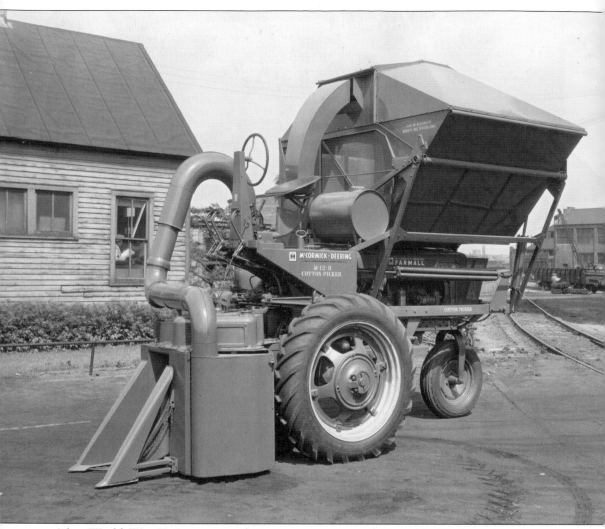

After World War II, International Harvester constructed Memphis Works, a huge cotton-picker factory located on the north side of the city, and manufactured the first pickers in 1949. Though the company had assembled experimental models for testing purposes, this event marked the first commercial production of mechanical cotton pickers. The plant's location clearly showed that the company aimed its pickers for use in the cotton areas of the Mississippi River Valley. Generations of Memphians worked at the manufacturing plant until labor troubles and eventual bankruptcy closed the operation in 1983.

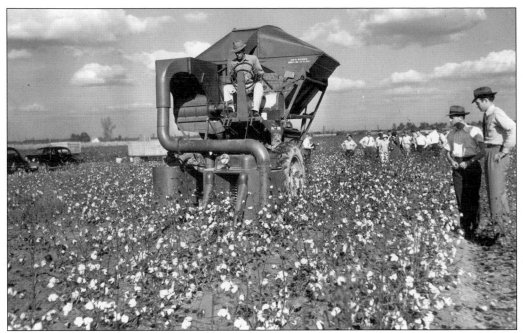

A crowd gathers to watch as this one-row picker marches through the cotton field at an unheard of rate of three miles per hour. The people of the South were mesmerized by this machine that would free them from the backbreaking drudgery of picking the white gold.

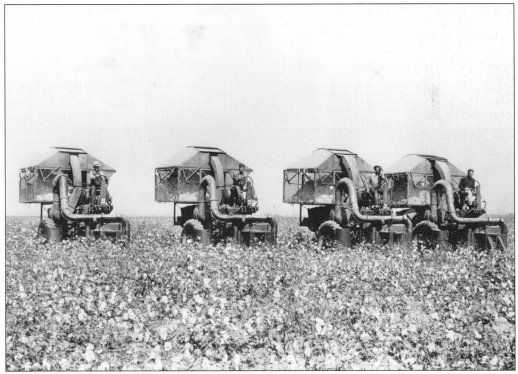

This line of Farmall cotton pickers races over a field in record time. A single mechanized picker could pick as much as a bale an hour, drastically cutting the harvest time.

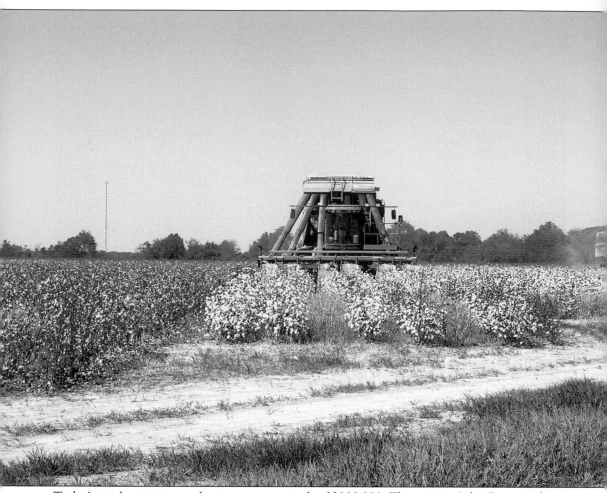

Today's modern cotton pickers can cost upwards of $300,000. This six-row John Deere with an air-conditioned cab and GPS technology can pick thousands of pounds a day.

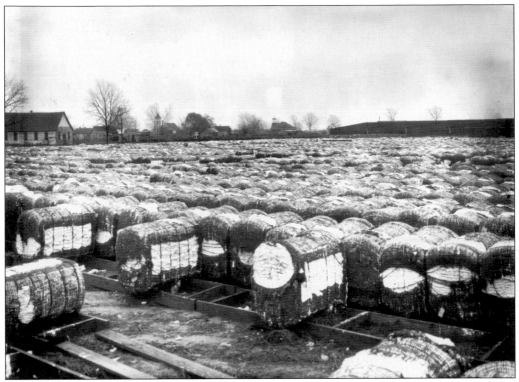

A veritable sea of cotton bales awaits the trip to the compress. Bales were initially pressed at the cotton gin but were re-pressed to more exacting standards at the compress and warehouse.

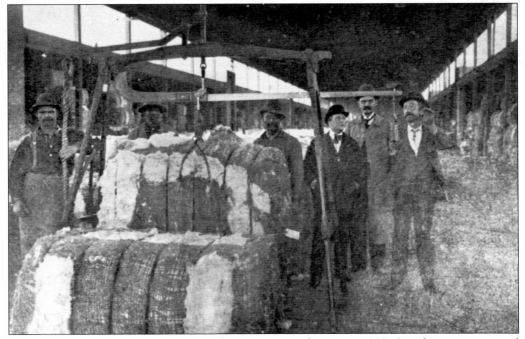

Shown here is a scene from a Memphis cotton warehouse in 1900. Jewish immigrant and Memphis cotton man Abe Frank is in the dark suit.

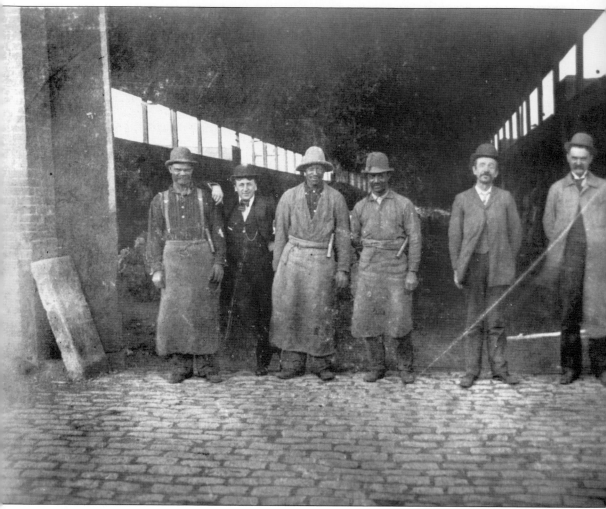

This 1895 photograph illustrates the diverse mix of workmen in Memphis around the turn of the century. German, Irish, Jewish, and Italian immigrants worked side by side with African Americans in the cotton warehouses, on the wharf, and in the cotton offices on Front Street. In 1900, African Americans comprised more than 58 percent of the Memphis population.

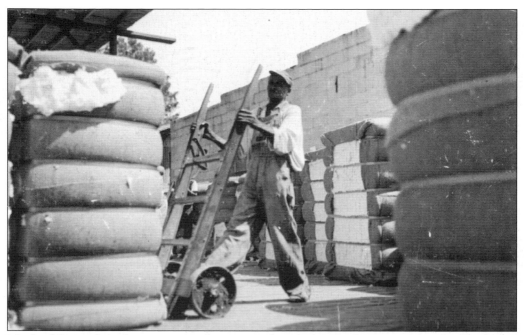

Much of the work in the cotton warehouses was done by hand. This man moves the 500-pound bales of cotton with nothing more than this two-wheel hand truck.

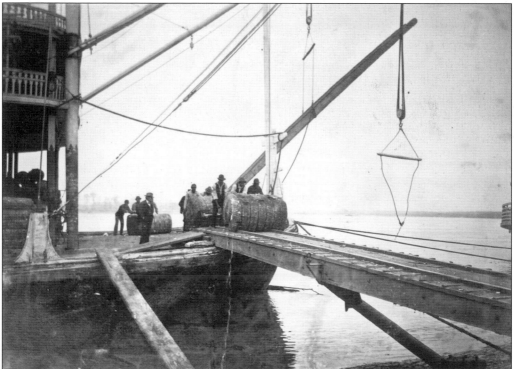

The Mississippi River packet boats played an enormous role in the transport of the cotton crop. The Memphis wharf was at times covered with cotton bales waiting to be taken up the bluff to the warehouse district.

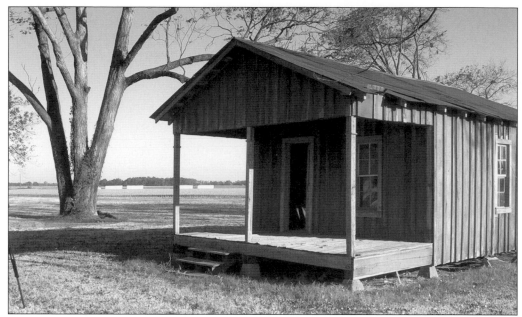

An abandoned sharecropper "shotgun shack" stands empty by a Delta cotton field. Sharecropping was a way of life for generations of Southern African Americans. By the beginning of the 1960s, farm mechanization and the migration of millions to cities in the North changed the face of the rural South.

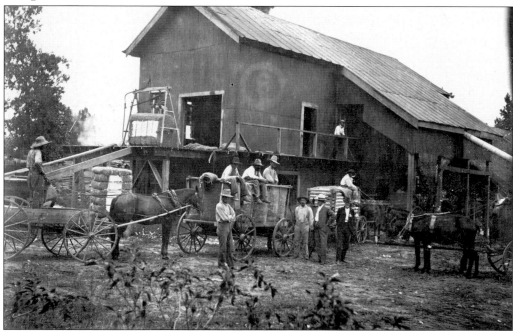

Along with the mechanization of farming, a huge effect on the economy was realized with a sudden dependence upon cotton production. Entire regions were forced to depend on the price and profusion of a single agricultural crop. When the cotton industry faltered, so did the South. On the other hand, when the year's crop was good, many farmers overproduced, which sometimes resulted in price drops that proved to be disastrous to many growers.

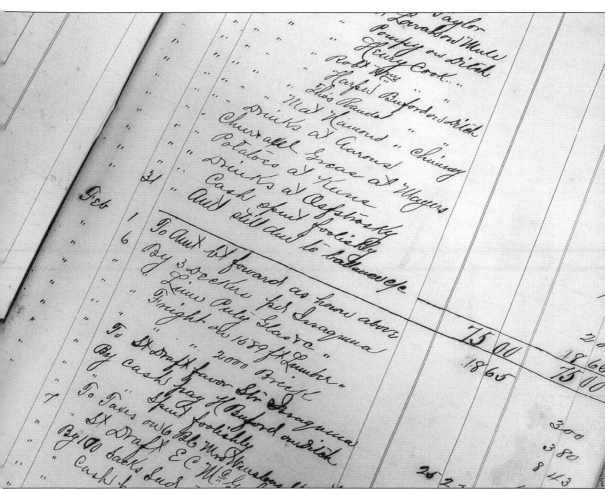

Under the system of sharecropping, families contracted to work a particular parcel of land, giving a percentage of the crop—almost always cotton—in exchange for a semblance of independence. The white landowners quickly regained dominance over their African-American partners. By controlling the local stores that the tenants relied upon, by charging excessive interest on anything purchased with credit, and by maintaining full control of the marketing of the crops, the landowners trapped the black sharecroppers into a labyrinth of peonage. In 1912, sharecropping still prevailed in the South, where over 90 percent of African Americans still worked in agriculture, almost always for someone else. This page from an 1890s plantation journal contains entries reflecting the supplies and cash furnished to the sharecropper family. This paternalistic practice is clearly seen in the entry near the bottom of the page that states that the money was "spent foolishly." (Photo courtesy Frank Stuart.)

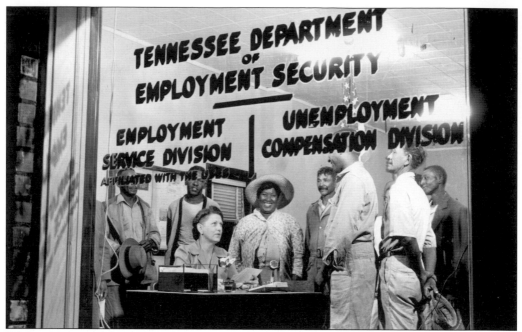

Well into the middle of the 20th century, seasonal farm labor was needed to work the cotton crop. A 1951 article in the *Memphis Press Scimitar* reported, "Signing up inside the farm labor office Mrs. Clara Kitts, Director, issues orders for work to the pickers. When orders have been filled and trucks are rolling Mrs. Kitts goes to the fields for a check of activity. 'Money's waiting at the end of the row' was the luring call to Memphis area prospective cotton pickers."

The advantage of running water, a wood stove for hot coffee, and facilities for making sandwiches were offered by some enterprising Memphians who operated trucks—"Pickers Pullmans"—to take laborers to the Arkansas and Mississippi fields, such as this one D.C. Sims operated in 1950.

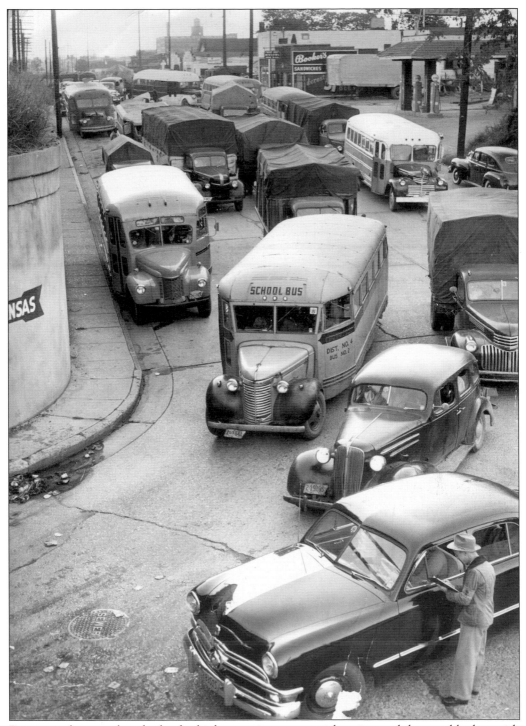

Bumper to bumper, hundreds of vehicles carrying cotton pickers jammed the two-block stretch of West Virginia just east of Harahan Bridge to be checked out by the Tri-State Farm Office of the Tennessee Department of Employment Security. A total of 10,490 pickers cleared through the office for work in Mid-South cotton fields on October 13, 1950.

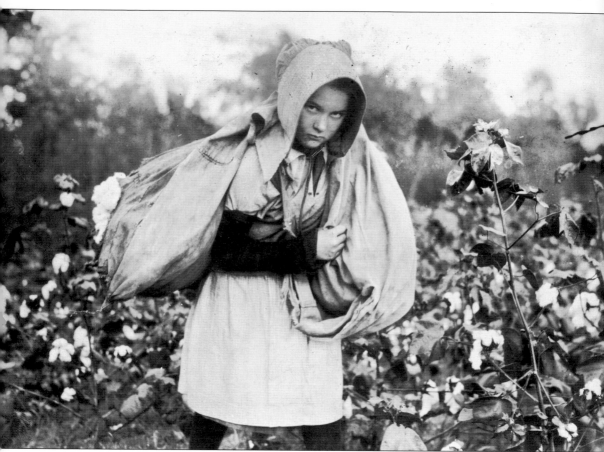

This striking photograph was taken by Lewis Wickes Hine in Potawotamie County, Oklahoma, in 1916. Hine was the photographer for the National Child Labor Committee, contributing to exhibitions and the organization's publication, *The Survey*. Declaring that he "wanted to show things that had to be corrected," he was one the earliest photographers to use the photograph as a documentary tool. Eleven-year-old Callie Camp could pick 75 to 100 pounds of cotton per day, and tote the 50-pound sack when it got full. Her comment to Hine on that October day was, "No, I don't like it very much."

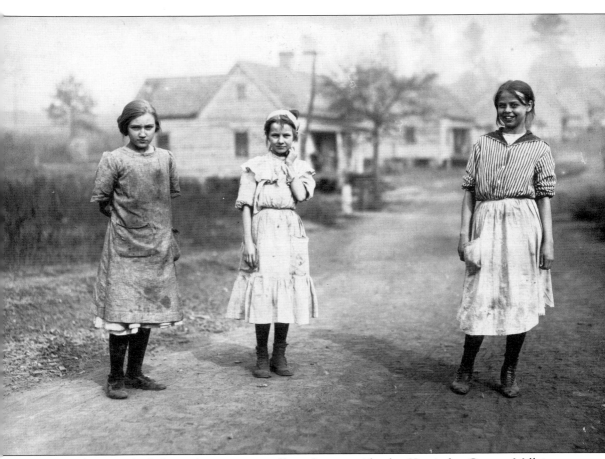

Hine photographed these three young mill workers outside the Kosciusko Cotton Mill in Mississippi, because the mill superintendent objected to his taking photographs on mill property. In Southern cotton mills, 25 percent of the employees were below the age of 15, with half of these children below the age of 12.

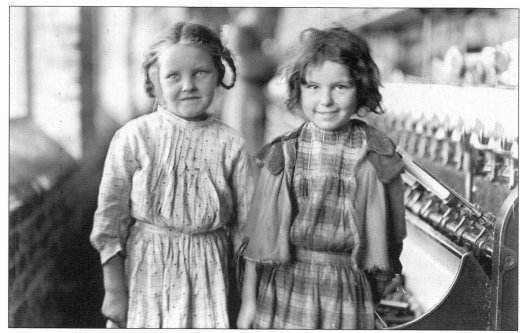

Two of the "helpers" in the Tifton Cotton Mill in Tifton, Georgia, are pictured here. It was reported that they worked regularly. Like their sharecropper counterparts, poor mill-worker families counted on every family member to contribute to the household income.

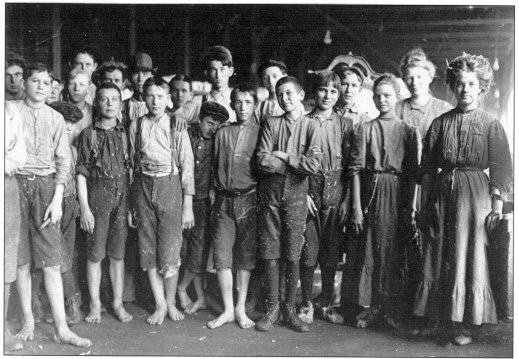

These children should have been posing with their classmates for a school photograph. Instead, they pose during a short lunch break with their fellow workers at a cotton mill in Augusta, Georgia, in this 1909 photograph.

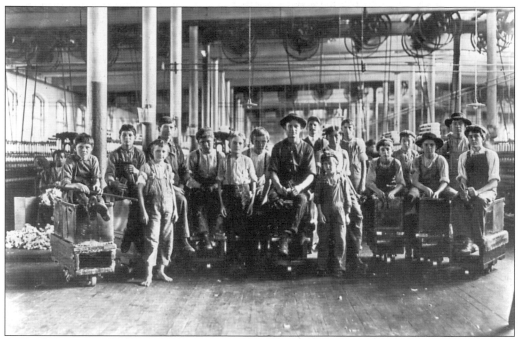

Around the turn of the 20th century, child labor committees pushed reform through state legislatures. Laws that restricted child labor were passed as part of the progressive movement of this period. However, the disparity that remained, particularly in the Southern states, led to a decision to work towards a federal child labor law. U.S. Congress passed these laws in 1916 and 1918, but the Supreme Court soon declared them unconstitutional.

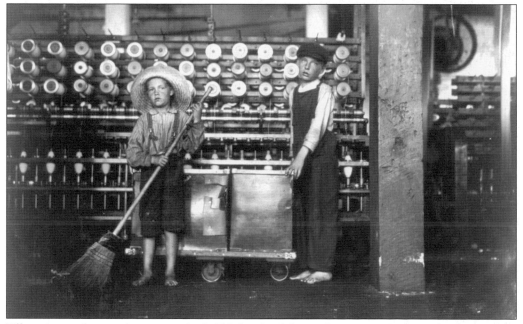

Efforts to regulate or do away with child labor have been characteristic of social reform in the United States since the early part of the 20th century. Leaders in this effort were the National Child Labor Committee, organized in 1904, and the various state child labor committees.

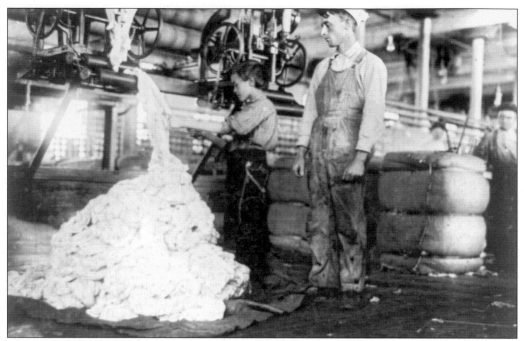

The Depression of the 1930s changed political attitudes in the United States considerably, and child labor reform benefited. Most policies and regulations developed under the National Industrial Recovery Act functioned to reduce child labor.

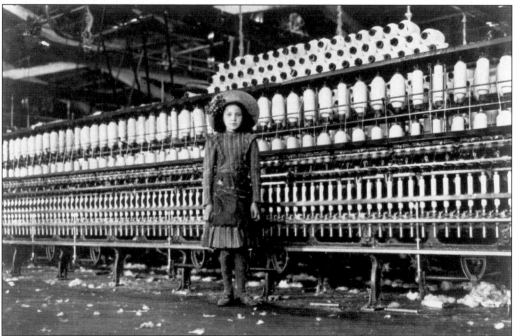

In 1938, the Fair Labor Standards Act set national minimum wage and maximum hour standards for workers engaged in interstate commerce. It also placed strict limitations on child labor. To a great degree, the employment of children under 16 years of age was banned in the manufacturing and mining sectors.

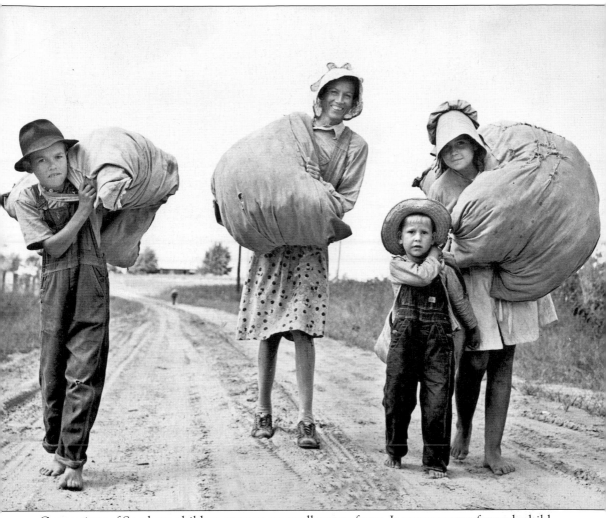

Generations of Southern children grew up on small cotton farms. It was necessary for each child to shoulder part of the responsibility for feeding and clothing the family. The hardships of living on a farm sent many of these children to nearby cities as soon as they were old enough to leave. City life in places like Memphis, Birmingham, and Atlanta was a welcome relief from the drudgery and isolation of the farm.

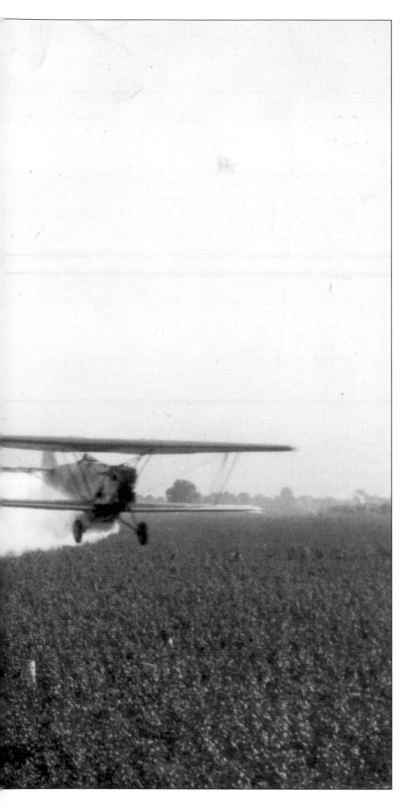

Delta Airlines had its beginnings as the world's first aerial crop dusting service in 1924, in Louisiana. The company became Delta Air Service in 1928. Delta inaugurated airline service on June 17, 1929, with the first passenger flights traveling a route from Dallas, Texas, to Jackson, Mississippi, by way of Shreveport and Monroe, Louisiana. In 1941, the company moved its headquarters to Atlanta, Georgia, from Monroe, Louisiana. To solve the issue of achieving a uniform distribution of defoliants and insecticide over the cotton field, the cotton farmer resorted to a new mechanical innovation: the airplane. Application of calcium arsenate by airplane and ground dusters in the war against the boll weevil resulted in savings of hundreds of millions of dollars worth of cotton and in better cotton for world markets. Even today, the use of aerially applied defoliants assures cleaner and higher grade mechanically picked cotton.

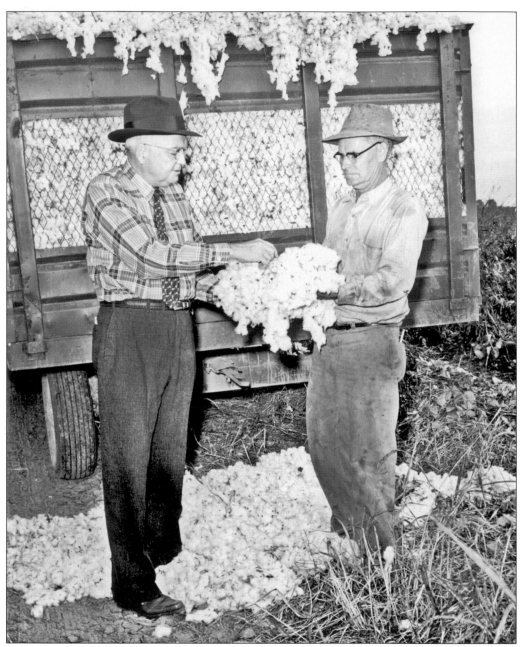

U.S. Sen. James Eastland from Mississippi was also a cotton farmer. In this 1958 photograph, he checks the machine-picked cotton with driver John Kittrell. During and after World War II, the South was caught up in a complicated web of economic realities. The region had suffered shortages of agricultural labor because of the migrations of African Americans and poor whites during the war. This led to the collapse of the old plantation system. The number of sharecroppers and tenant farmers declined progressively, and eventually, the U.S. Department of Agriculture ceased counting them after the 1959 census. The very composition of Southern agriculture changed as the number of farms progressively declined, while the physical size of individual farms increased. The age of Agri-Business had arrived.

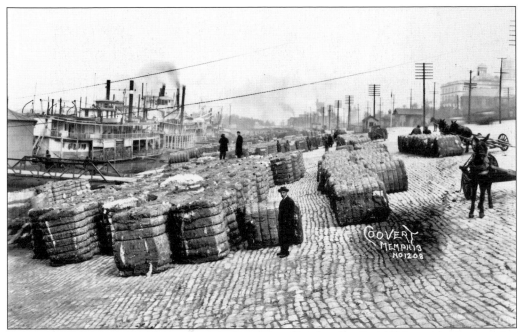

Cotton bales line the cobblestones of the Memphis wharf at the foot of Union Avenue in this *c.* 1900 image by Memphis photographic legend J.C. Coovert. By the fall of each year, cotton was truly everywhere around the city.

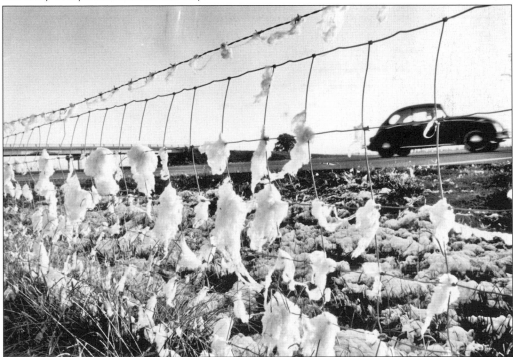

Cotton does not grow on trees, but one could get the impression that cotton grows on fences. This is a familiar sight along roadsides throughout the Mid-South, where in the fall, cotton covers everything.

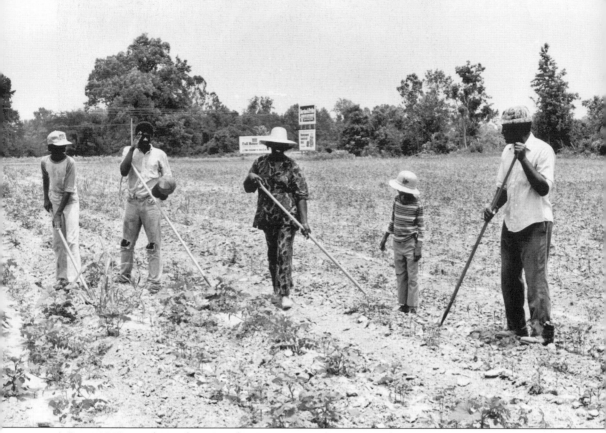

A June 1982 article in the *Memphis Press Scimitar* reports, "Chopping cotton is a family affair for the Charles Pruitts who have a 40 acre farm near Covington, TN. They raise their own vegetables, kill and preserve their own meat, and chop their cotton by hand. Jacob 12, Joseph 14, Ms. Pruitt, Cynthia 8, and Charles Pruitt." Small farmers continued to grow cotton through the 1980s, mainly as a means of extra money for the household. Increasing production prices and a volatile market have finally nearly wiped out the small cotton farmer in the South.

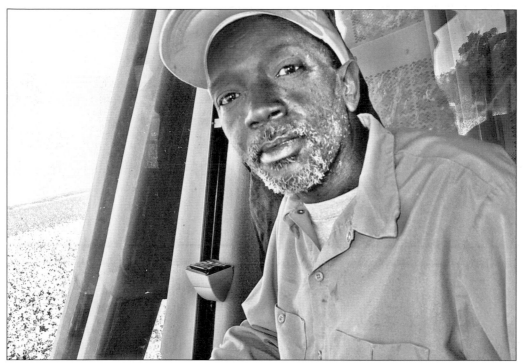

Driver Isaac Stamps guides the six-row John Deere cotton picker through this Mississippi Delta field doing the work of a hundred men, women, and children of an earlier time. Technology continues to change the face of the rural South.

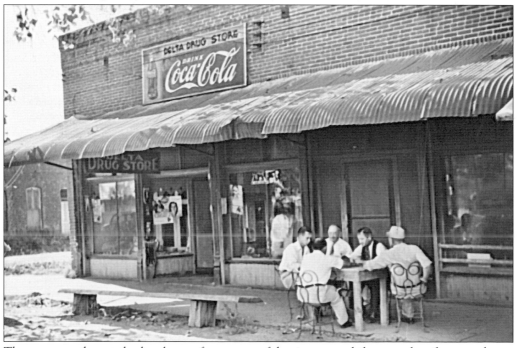

These men gather at the local store for a game of dominoes to while away the afternoon hours during the middle of summer. The crop was said to be "laid by," awaiting the fall harvest.

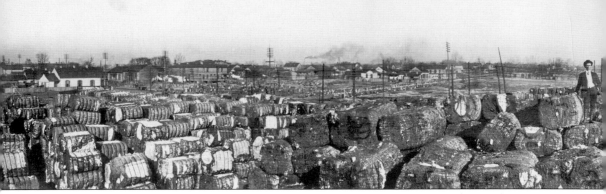

This January 1907 photograph by J.C. Coovert is perhaps the crowning glory of his career in documenting the cotton business in the South. A seemingly endless sea of cotton bales covers this south Memphis scene. The value of the cotton crop in 1897 was nearly $320 million, and

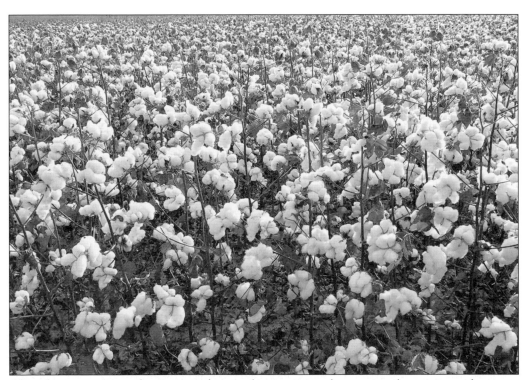

After the uncertainty of spring weather at planting time, the worries about too much rain or not enough rain, too much sun or not enough sun, the price of fuel, and a thousand other concerns, this field of cotton is finally ready to pick.

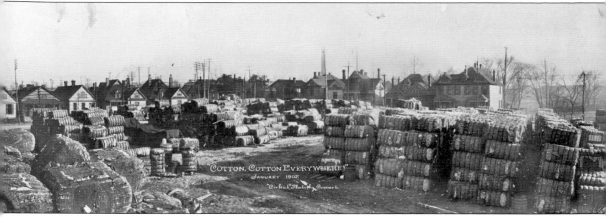

each year, more was grown for domestic trade while exports continued to be enormous. The world market for cotton was established and continued to grow even with the introduction of cheaper man-made fabrics such as nylon and rayon.

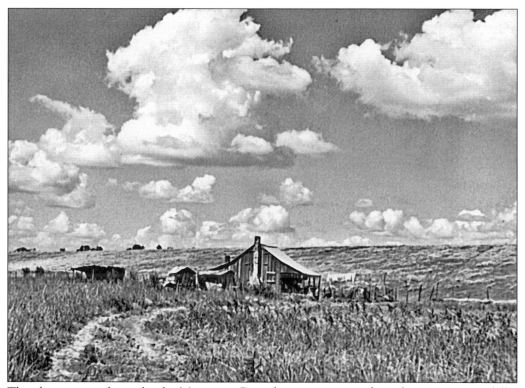

This sharecropper home by the Mississippi River levee is an image from the recent past. Idyllic as it looks, the work was hard, the hours long, and the pay low.

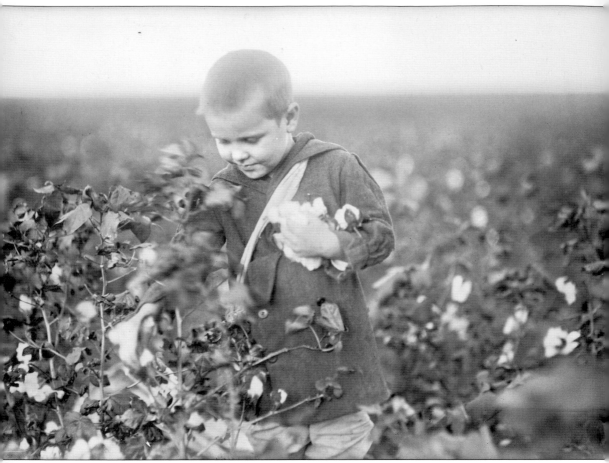

In one of the most poignant photographs of the era, this young child does his part in the cotton field to help his family make it through another year. Surprisingly few photographs exist of African-American children working in the fields, certainly not as a part of the National Child Labor photograph collection. The reason is unclear, but perhaps the anomaly of a white child working in the field or in a factory was considered a better photographic opportunity.

Three
THE BUSINESS
OF COTTON

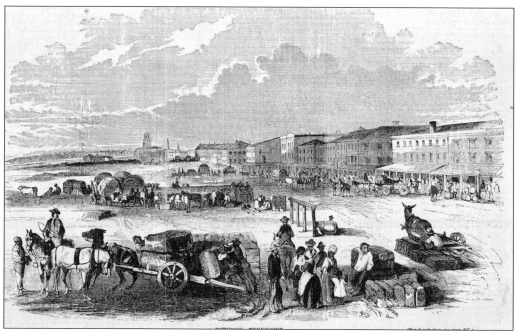

This 1845 illustration tells the entire story. Even then, cotton was at the heart of the Memphis business community, and the wharf bustled with the activity of passengers and commerce.

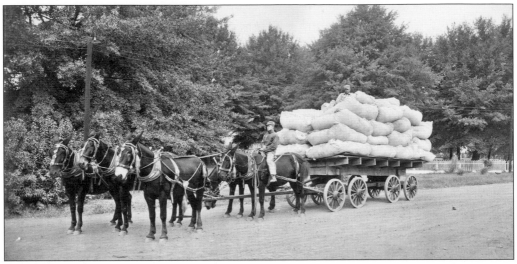

Wagons pulled by mule teams were a common sight on the roads leading to Memphis. Cotton farmers from west Tennessee, eastern Arkansas, and the Mississippi Delta sent their cotton crops to the Memphis market for distribution to the world.

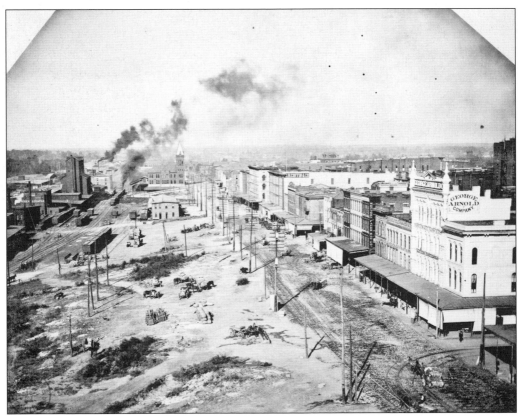

This 1895 photograph, looking north from the cobblestones of the wharf, shows Front Street in all its bustling glory. The nearness to the river made Front Street the logical location for cotton merchants.

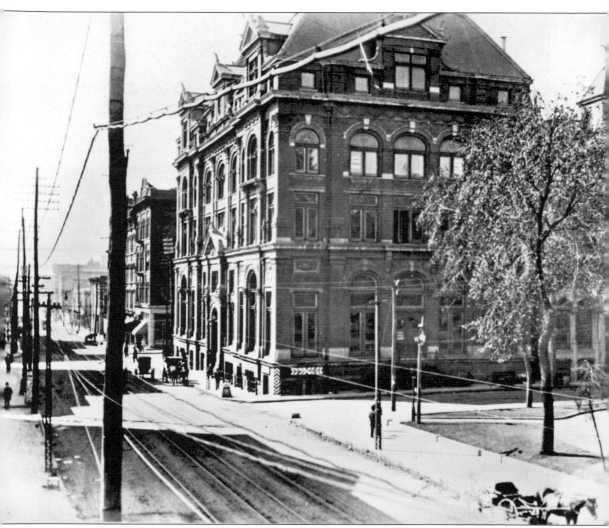

The Memphis Cotton Exchange was incorporated April 20, 1874, by the following charter: "State of Tennessee. Be it Remembered, That on to-wit, April 20th, 1874, in the Second Chancery Court of Shelby County, Tennessee, Hon. Sam'l P. Walker, Chancellor, the following proceedings were had and appeared of record, to-wit: No. 1041. Schoolfield, Hanauer & Co., and others, Petitioners, Ex Parte, To incorporate 'The Memphis Cotton Exchange.' The purposes of the Cotton Exchange are set forth in the second article of its constitution, as follows: Section 1. The purposes of this Association shall be to provide and maintain suitable rooms for a Cotton Exchange in the city of Memphis; to adjust controversies between members; to establish just and equitable principles, uniform usages, rules and regulations, and standards for classifications, which shall govern all transactions connected with the cotton trade; to acquire, preserve and disseminate information connected there-with; to decrease the risks incident thereto; and generally, to promote the interests of the trade, and increase the facilities and the amount of the cotton business in the city of Memphis."

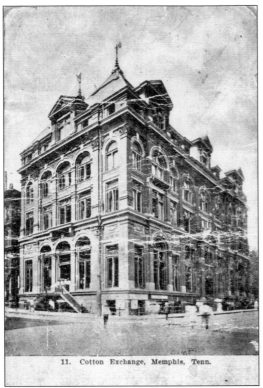

11. Cotton Exchange, Memphis, Tenn.

The following description of the building, which was taken possession of September 1, 1885, and which cost $145,000, is taken from the Memphis *Avalanche* of that date: "Viewed from the outside one is deeply impressed with the grandeur of the building that today will be taken formal possession of by the sister exchanges. It is at once solid and ornamental in appearance. The skill of the architect and the conscientiousness of the builder are plainly apparent in every feature of the structure. It is four stories high and of the Gothic style of architecture. The frontage is resplendent with artistic ornamentation. An air of elegance pervades the entire building and there is not the slightest suggestion of gingerbread work anywhere."

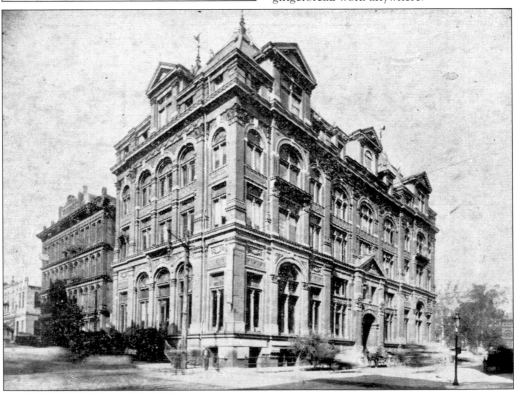

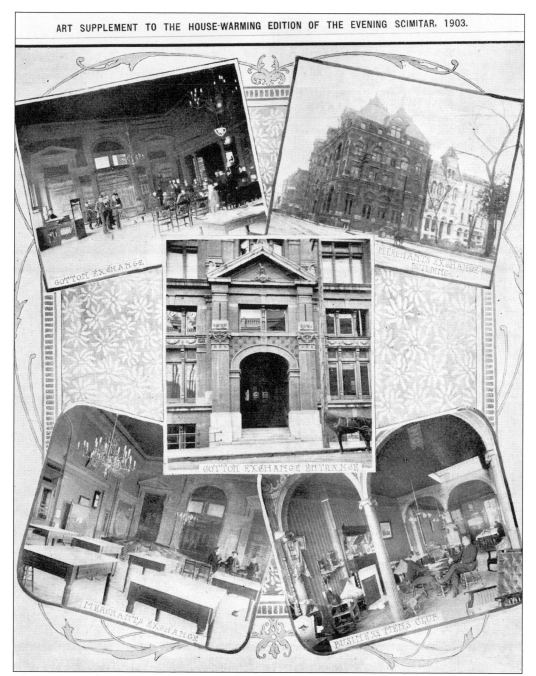

This 1903 supplement to the housewarming edition of the *Memphis Evening Scimitar* shows the Memphis Cotton Exchange in its glory. Aside from the downtown hotels, it was the most elegant building in Memphis.

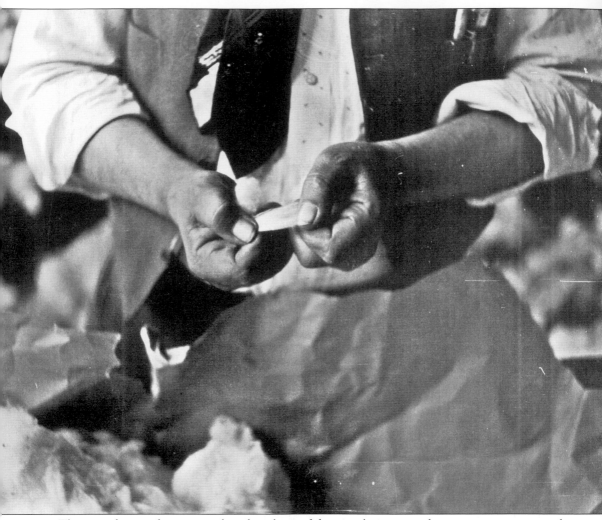

This time-honored practice is largely a thing of the past, but seasoned cotton men can instantly tell the quality of the fiber by pulling the staple. Modern government standards have taken the guesswork or conjecture out of determining the grade of a particular cotton sample, but generations of merchants used this method, recognized today as the archetypal image of the cotton trade.

Memphis cotton merchant Abe Frank checks samples in his Front Street office in this 1903 photograph. The Memphis cotton trade was diverse, including almost every ethnic group represented in the community. Frank was the son of Jewish immigrants Henry Frank, born in Lust, Bavaria, and Rose Kalish, born in Posen, Prussia. The Franks established themselves as successful cotton factors in Memphis during the Civil War.

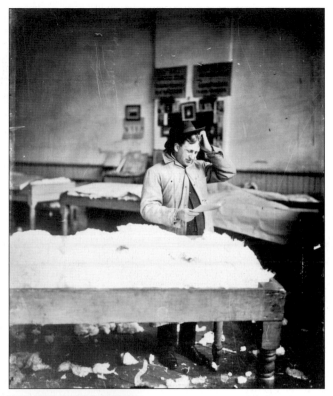

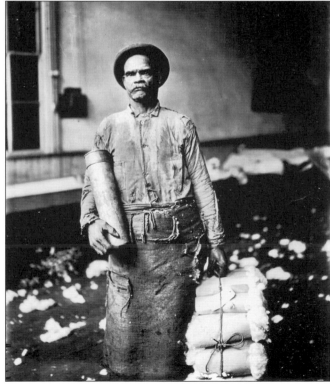

Porters were employed to bring cotton samples to the classing rooms for the merchants to determine the quality of the cotton. After the samples were tested, they were sent out for re-baling.

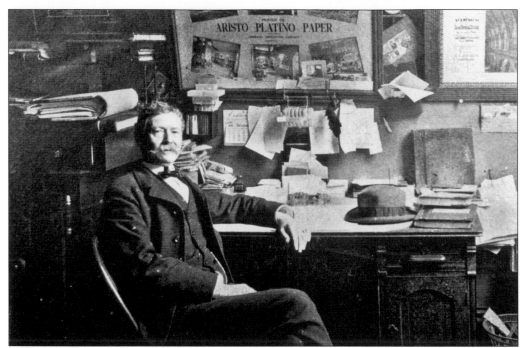

Godfrey Mayor, cotton factor, has his formal photograph taken in the office of Godfrey Frank at 73 Union c. 1900. The role of the cotton factor was essential to the growth of the cotton business in the South. Factors raised money from large banks and then supplied funds to farmers for that year's crop. The crop, and generally the farm itself, would be pledged as collateral. This system kept markets fluid because the factor had control of the crop.

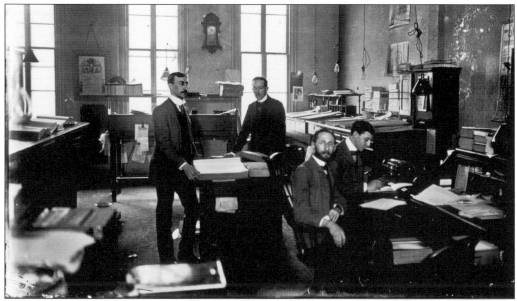

Pictured in the office of Godfrey Frank at 73 Union Avenue are, from left to right, Mencko Mayor, unidentified, R. Bernhold, and Abe Mayor. The men dressed in formal business attire in the office. The office was equipped with electric lights and a typewriter—high-tech for the turn of the century.

Another type of cotton merchant was the FOB merchant, who did not lend money on the crop. He simply got a commission from the farmer, much like a modern-day real estate agent.

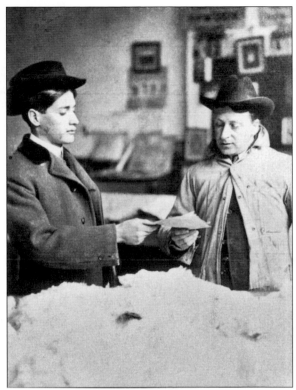

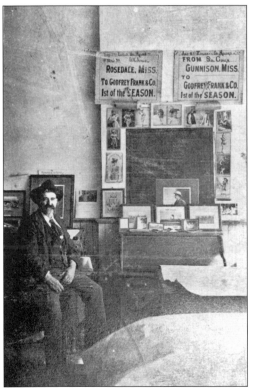

The cotton merchant was the "wildcatter" of the cotton trade. He had a relationship with the mill and moved the cotton from the rural gin to the mill while taking a profit. The merchant was out on the street, buying from everyone as cheaply as he could and then selling high as he could. Knowledge and relationships were key to his business.

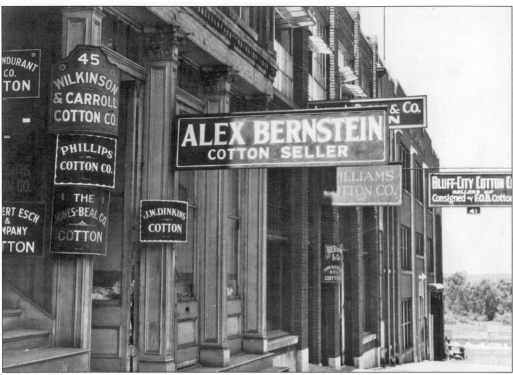

Cotton company signs line Union Avenue (top) and Front Street (bottom). Dozens of cotton buyers and sellers called Front Street and Union Avenue home during the first half of the 20th century. By the 1970s, cotton companies had begun to move from downtown Memphis to office parks and buildings in the suburbs.

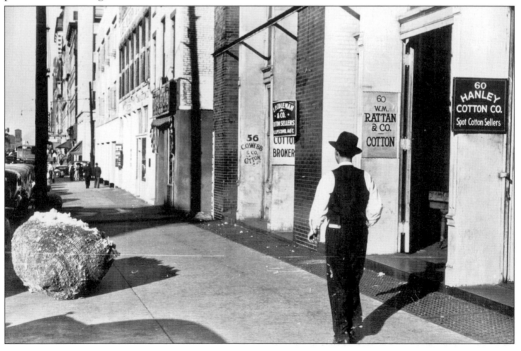

A cotton merchant stands outside his Front Street office in this 1939 photograph by Marion Post Wolcott. Wolcott worked as a Farm Securities Administration photographer between 1938 and 1941. The images show Americans at home, at work, and at play, with an emphasis on rural and small-town life and the adverse effects of the Great Depression, the Dust Bowl, and increasing farm mechanization.

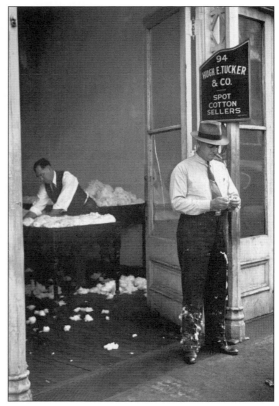

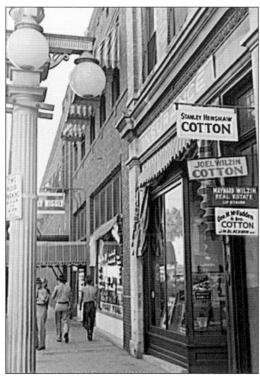

It seems that every Mississippi Delta town had offices for cotton buyers on its main thoroughfares. This street scene is of Leland, Mississippi, in the 1940s. Even today, Leland remains in the heart of the Delta cotton culture.

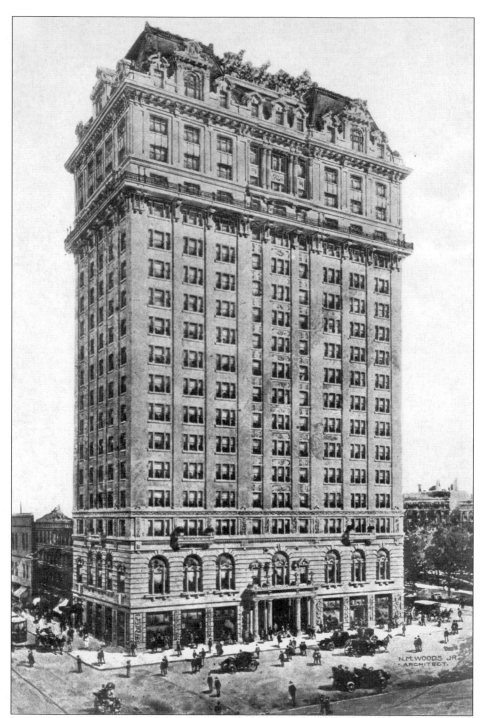

By the early part of the century, the Memphis Cotton Exchange had outgrown its 1885 building, and it began construction on the tallest building in Memphis on the same site at Madison and Second Street. The 19-story building opened in 1911. The *News Scimitar* described the lobby as "one of the most ornate in the South with an ornamental suspended ceiling, numerous pilasters and a three-story double set of marble and bronze stairs on the east side."

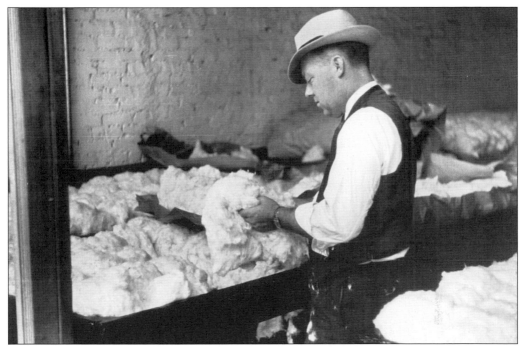

By the 1930s, the Great Depression had greatly affected the cotton trade, as it had the entire economy. Prices dropped, production increased, and the Memphis Cotton Exchange became the leader and spokesman for many groups urging producers to restrict acreage by one-third.

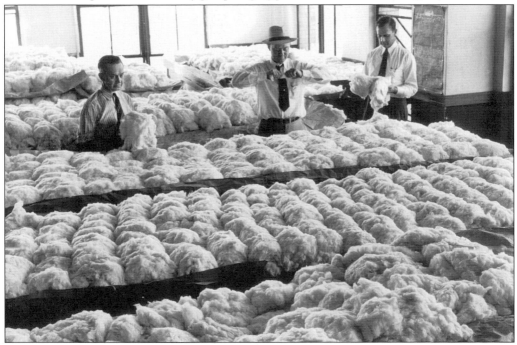

As the Cotton Exchange moved into the 1940s, the Memphis market was handling 31 percent of America's cotton production, and spot sales by exchange members for the first year of that decade were nearly equal to the combined sales of the other nine designated spot cotton markets.

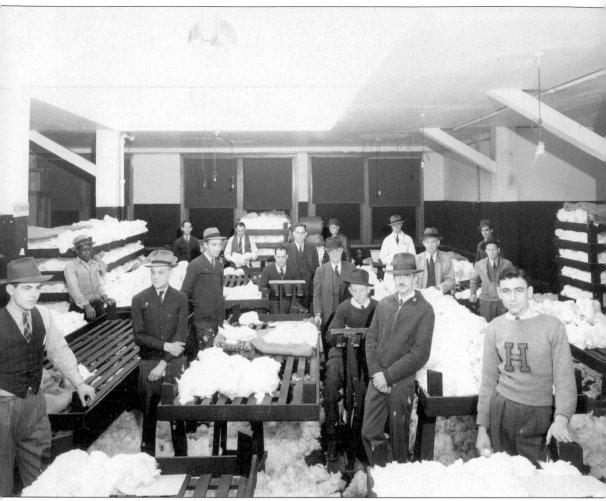

Cotton was one of the first major agricultural commodities grown in the United States. As the industry grew, the lack of uniform quality factors created increasing problems for the industry's national and international markets. In 1907, an international group of cotton industry representatives met in Atlanta, Georgia, to address serious problems that had developed in the marketing of cotton. A resolution was passed that recommended the establishment of uniform cotton standards to "eliminate price differences between markets, provide a means of settling disputes, make the farmer more cognizant of the value of his product, and, therefore, put him in a better bargaining position, and in general be of great benefit to the cotton trade."

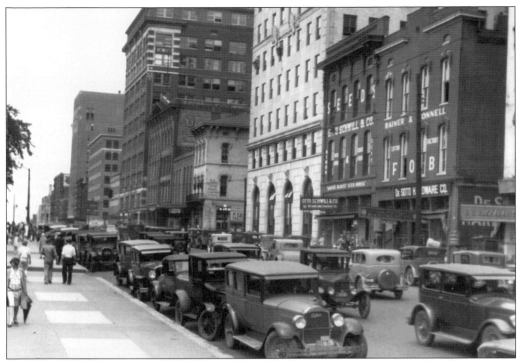

This 1930 photograph of Front Street is looking north toward Union Avenue. Downtown was the center of commerce and social life in Memphis until after World War II, when the first suburban shopping centers were built.

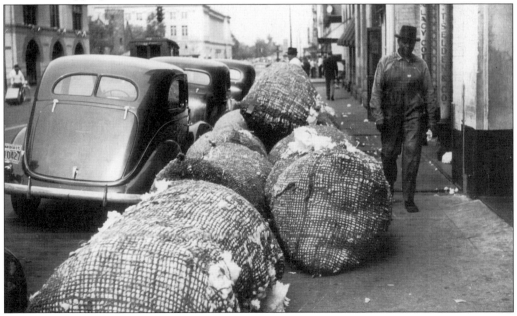

Like giant pillows, these cotton "snakes" await pickup on Front Street for re-baling. After wrapped samples were taken to the classing rooms, the cotton, now called "loose," was stuffed into giant burlap sacks, taken to the pickery, re-baled, and sold. Pickeries were setup to deal with secondary products.

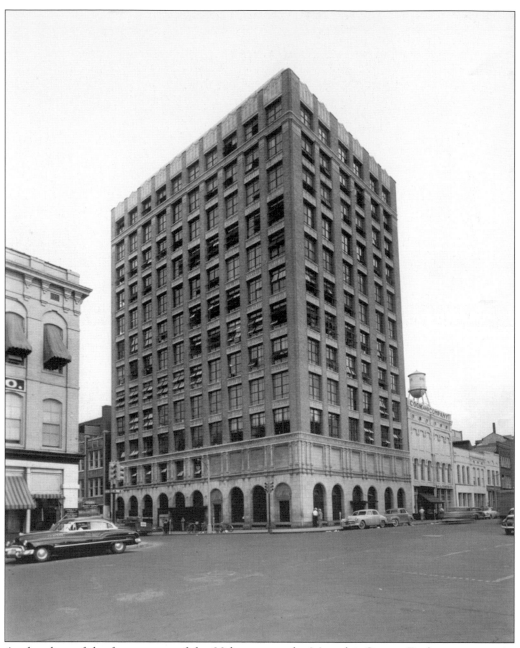

At the close of the first quarter of the 20th century, the Memphis Cotton Exchange was again on the move. In 1919, it was decided that the large building at Madison and Second was too remote from the center of cotton activity strung out along Front Street from north of Madison to beyond Gayoso. The exchange moved to a new building at the corner of Union and Front and remains there today.

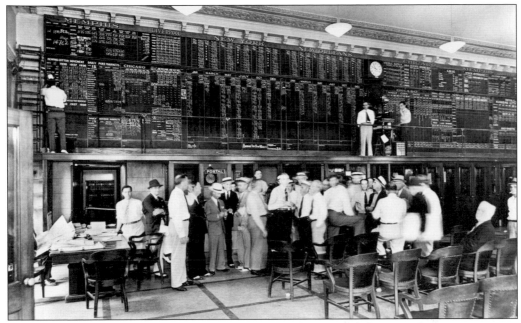

The "floor" of the Cotton Exchange is a high-ceilinged room with large windows opening onto both Front Street and Union Avenue. The other two walls of the room are completely covered with the "boards," where quotations of all future markets, the current spot prices, ginnings, acreage, consumption, and any statistic necessary to the conduct of the cotton industry are posted.

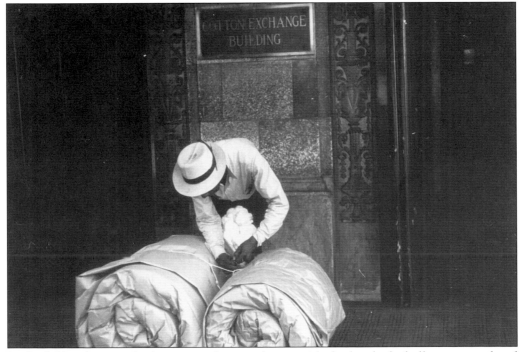

In the lobby above each elevator are bronze plaques with the head of a bull on one end and the head of a bear on the other. This reminder of the whims of the market was not lost on exchange members.

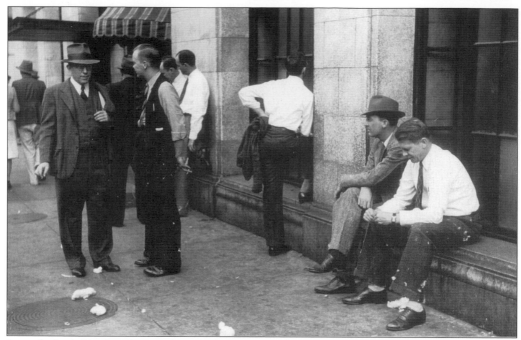

It might look like break time, but much of the cotton man's work was done off the floor of the exchange. Personal contacts were the name of the game in the cotton trade, and many deals were struck on the streets and sidewalks of downtown Memphis.

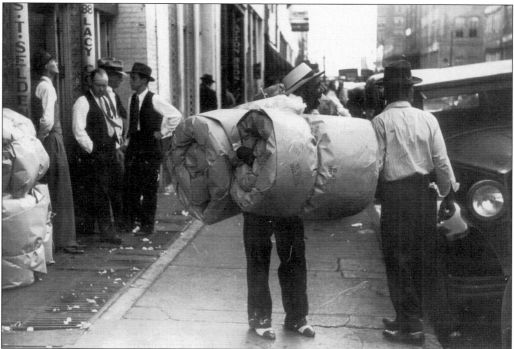

A man carries paper-wrapped samples to a classing room. Much of the inside information and gossip on the street came from porters and other workmen who moved about the street during their workday.

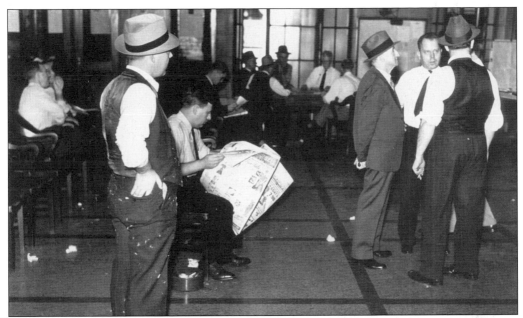

With cotton lint on his trousers, this trader checks the board for cotton prices. The Depression of the 1930s had hurt the cotton business, but World War II was about to change all that. The price of cotton began to rise as soon as it became evident that the United States would enter the war. The average price paid to farmers rose from 9.9¢ to 22.5¢ a pound.

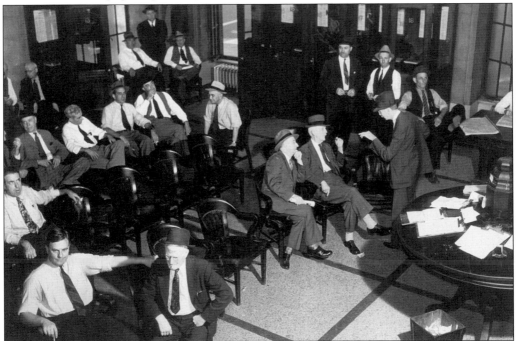

In the preceding decade, the problem had been how to dispose of surplus cotton. Now, with the advent of war, the question was how to produce enough cotton to satisfy insatiable demands. Many changes had to be made in the operation of the Memphis Cotton Exchange to comply with and augment the war effort.

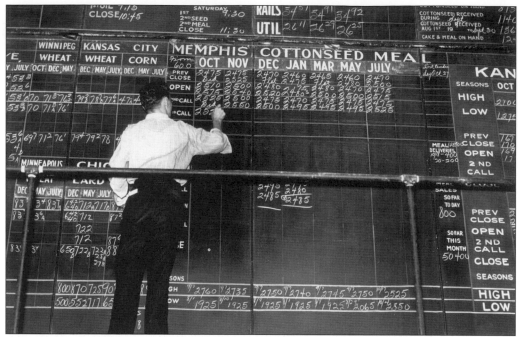

Many faces disappeared from the exchange during the years of the war, as individuals went off to serve their country in Europe and the Pacific. Information ceased to be available regarding the movement of spot cotton in and out of Memphis and daily reports of Memphis stock.

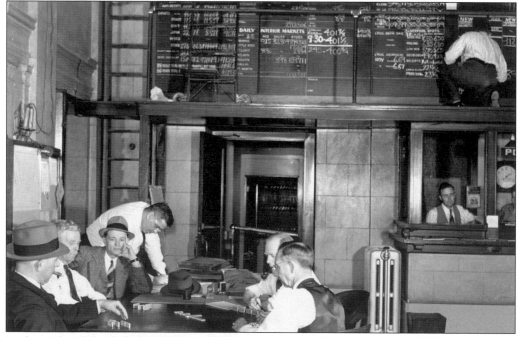

In the midst of the dark days, one item of levity appears in the request that "all those interested in dominoes refrain from starting their games until after the close of the future markets." These domino games, and, to a lesser degree, checkers, were an established way of life on Front Street to while away the long days of summer.

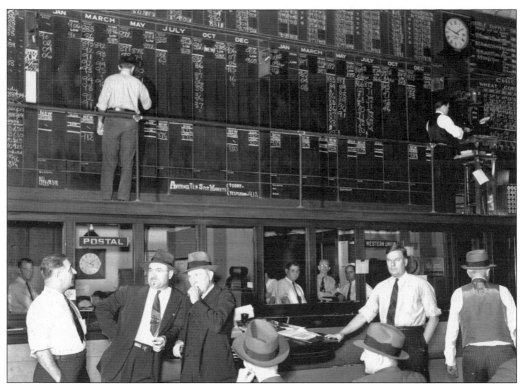

One thing that has not changed in the 131 years of the Memphis Cotton Exchange is the honor of the cotton market. The word of the cotton man is all that is needed for a transaction running into the millions of dollars. His "I'll take it," or "That's okay, put that down" is all that is necessary—no long and involved document, just word of mouth.

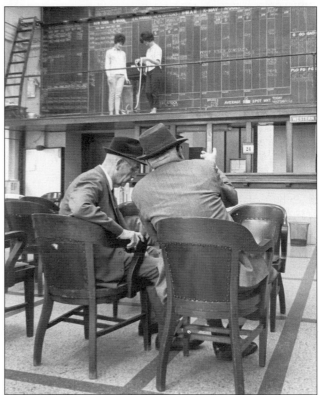

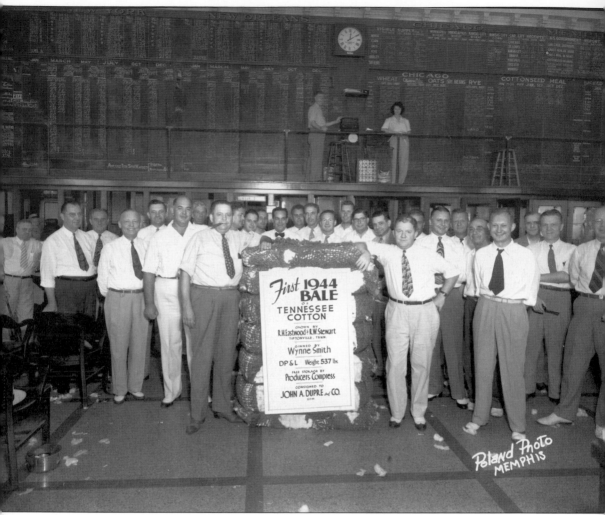

The culmination of the hopes, dreams, and good luck of the planter pays off in the first bale of the year. Members of the exchange pose with the first Tennessee bale of 1944, grown by R.H. Eastwood and R.W. Stewart of Tiptonville, Tennessee. With the gradual move away from Front Street, scenes such as this have become a thing of the past, but in its heyday, Front Street was the most important street in the cotton business.

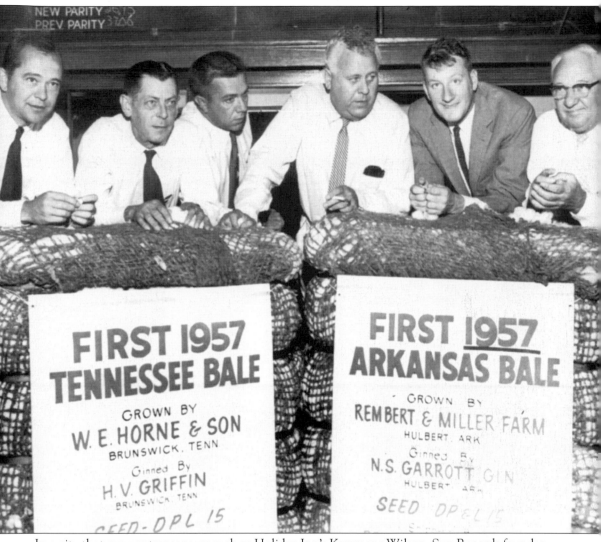

In a city that grew entrepreneurs such as Holiday Inn's Kemmons Wilson, Sun Records founder Sam Phillips, and Fred Smith of FedEx, Memphis cotton men were prominently represented on the world stage. Billy Dunavant was the first cotton man to sell to The Peoples Republic of China, and Edward Cook (second from right, posing with the first bales of 1957 Arkansas and Tennessee cotton) expanded his family's commodities business into an international powerhouse. Cotton merchants have set the pace for Memphis, both socially and economically for more than 130 years. The many legends are remembered not only for their business abilities, but for their many contributions to the lives of Memphians as well.

By the 1970s, Memphis was truly the international hub for cotton trading and the place to come for learning the cotton business. Here, Ricardo Berner, Vitali Mesualm, Johnny Young, Zeer Zur, and Gerrit Wesselink pose for a picture at a cotton classing office.

During a coffee break at a meeting of the National Cotton Council, George Brandow, Dr. Alexander Nunn, Edward W. Cook, and George Cortright discuss cotton legislation. The National Cotton Council was founded in 1938 to represent the interests of planters, ginners, warehousers, merchants, and associated industries. The council has been at the forefront of setting standards, developing marketing programs, and compiling economic information for its members.

Local beauties pose in the time-honored tradition beside the star of the South, cotton.

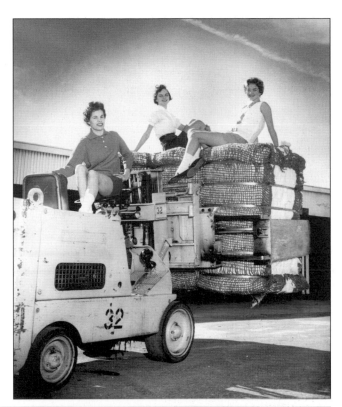

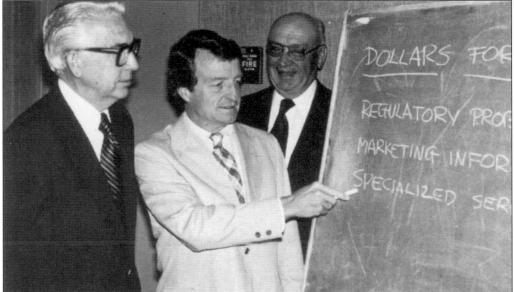

Mississippi cotton planter Frank Mitchener (middle) served as president of the National Cotton Council in 1981. During much of his career, Mitchener served the public interest by traveling the globe in cotton's behalf and serving on trade missions and advisory councils. Among his firsts was the adaptation of computers to his farming and ginning operations. His lifelong commitment to civic service has been widely recognized, and he has set the bar for generations of cotton men to come.

This item from the *Memphis Press Scimitar*, c. 1985, reads "Picking cotton. Farmers and ginners from across the south came to Memphis this weekend for the Mid-South Farm and Gin Show at the Cook Convention Center to catch up on the latest cotton news. Attending with his grandfather J.W. Denman was Darin Griffis, left, of Memphis, who purchased this souvenir from Brenda Williams."

Although most of the cotton classing rooms are long gone from Memphis's Front Street, ECOM USA's Calvin Gray trays up cotton samples in preparation for classing in one of the last downtown classing rooms. (Photo courtesy of Robin Salant.)

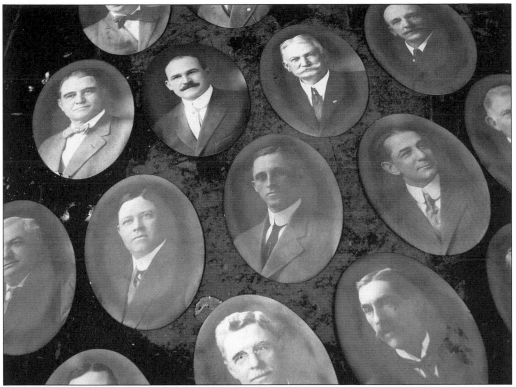

These photographs are the formal portraits of members of the Memphis Cotton Exchange *c.* 1900.

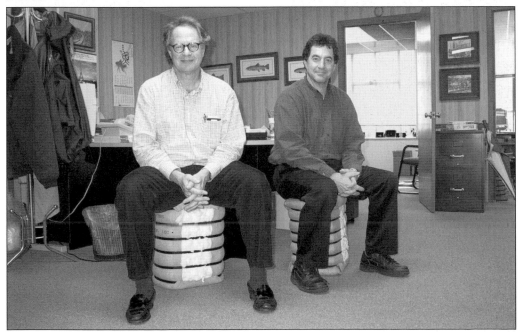

Modern day cotton men Calvin Turley (left) and Danny Lyons sit on small cotton bales in their Cotton Exchange Building office.

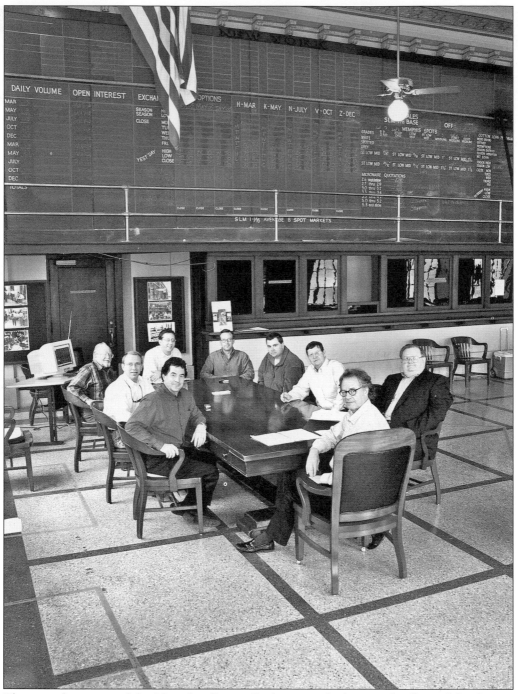

The annual meeting of the Memphis Cotton Exchange took place on the floor of the Cotton Exchange on January 12, 2005. It was the 131st annual meeting of the exchange. From left to right are Pete Moffitt, Mike Farrish, Scott Sivils, Danny Lyons, John King, David Vickers, John Leary, Calvin Turley, and Fred Richardson.

DATE	NAME	CITY, STATE, COUNTRY
09/02/04	LUCA SAVERINI	FIRENZE ITALIA
9/20/04	DAVID BOWMAN	SEWANEE, TENNESSEE
10/5/04	A + J. Jameson	Gainesville, FL
10/8/04	SHIGENORI UENO	TAKARAZUKA, HYOGO, JAPAN
10/8/04	SHINYA SOGA	OZU-CITY, EHIME. JAPAN
10/8/04	Hiroyuki Fukushima	Ibaraki, Osaka, Japan
10/06		Beijing China
10/8	GREGORZ MALEWICZ	KIELCE, POLAND
10/6	Li Yu	

As evidenced by the register, visitors from around the world come to the Memphis Cotton Exchange every year. In 2005, the exchange will open as a museum with interactive exhibits, oral histories, the Cotton Hall of Fame, cotton society, and a recreation of Front Street and the trading floor from 1940.

93

Brothers Gil (left) and Howard Stovall play in the cotton field at Stovall, Mississippi, in this *c.* 1965 photograph. The Stovall family has farmed the same land since their first ancestor came to the Mississippi Delta and cleared the timber in the 1840s.

The Stovall brothers, Gil (left) and Howard, are pictured in the same cotton field in 2004. Stovall Plantation was the site for one of the seminal moments in the development of blues music. Library of Congress researcher Alan Lomax first recorded bluesman McKinley "Muddy Waters" Morganfield on Stovall Plantation in 1941.

Four

COTTON SOCIETY

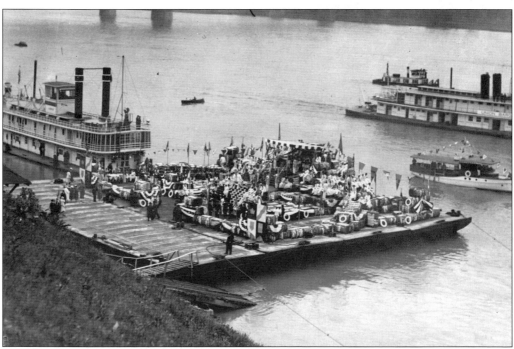

As a natural result of Memphis's financial dependence on cotton, a society based on the sale and glorification of the plant emerged. The most outstanding example of this phenomenon was the Memphis Cotton Carnival. A. Arthur Halle, one of the original founders of the Cotton Carnival, wrote, "Just as the Mystic Society of the Memphis was founded in 1872 to help Memphis recover from a period of depression and half despair, so the Memphis Cotton Carnival was organized in January 1931 to 'further the uses of cotton, make people in all sections of this great land of ours more cotton-conscious, do everything in its power to get more men and women to wear cotton apparel, tell the world through all kinds of publicity and advertising about cotton, and to promote, publicize and advertise, to the world, the city of Memphis, which, those of us who live here, think is the finest city in these United States.'"

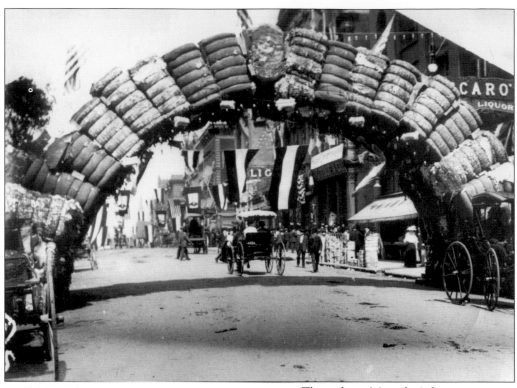

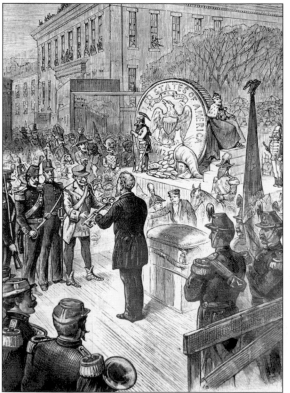

Throughout Memphis's history, cotton has always been acknowledged as the foundation and livelihood of the city. In this 1907 snapshot, cotton merchants have fashioned an arch out of huge cotton bales, framing a street in downtown Memphis. Cotton was king even in this early time, a trend that would continue until the Great Depression rocked the city.

On the origins of the Memphis Cotton Carnival, past carnival president W. Neely Mallory wrote, "It all began one afternoon in January, 1931, when Herbert Jennings, then manager of Loew's theaters in Memphis . . . unfolded a plan for what he called a 'cotton week' celebration." From that day, prominent business leaders were brought from all over the city to form the Memphis Cotton Carnival Association. By the time the association was formed, there was only one month to plan the first carnival, whose theme was "The Old South."

Written in 1901, this self-ascribed "Ballad Hit of the Century" was one of the earliest collaborations between composer Harry Von Tilzer (née Harry Gummbinsky) and Andrew Sterling. "Down Where the Cotton Blossoms Grow" was part of the popular Dixie style of music; however, it could also be classified as minstrel.

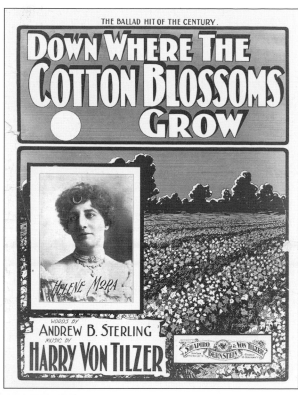

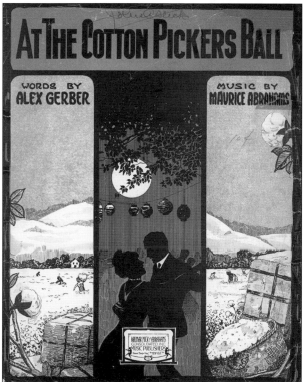

Originally published in 1917, "At the Cotton Pickers Ball" was a typical African-American dance number. Maurice Abrahams was a popular composer and lyricist at the time. This song is reflective of the pervasive nature of cotton culture in the early part of the century.

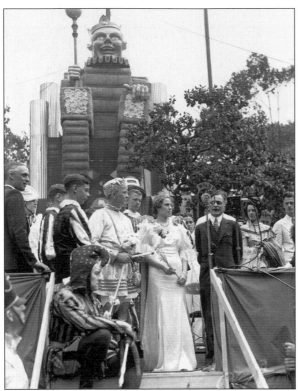

King Cotton looms large over this Cotton Carnival Royal Court in the 1930s. The carnival has such national appeal that both CBS and NBC carried descriptions and programs of all the proceedings to major radio stations all over the United States.

This snapshot gives a great perspective of the immensity of the royal court procession from barge to shore. Note the hoop skirts; this was most likely the "Old South" themed carnival of 1931.

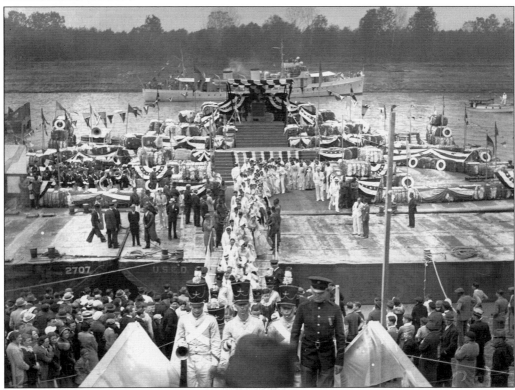

This magnificent costume was quite befitting the queen of this early Cotton Carnival. The carnival brought a new demand to the cotton industry: ready-to-wear cotton evening gowns. Before the 1931 Cotton Carnival, cotton evening gowns were practically unheard of. In a year's time, the style was in demand across the country. This was one of the more ingenious methods used in the carnival to bolster the cotton industry.

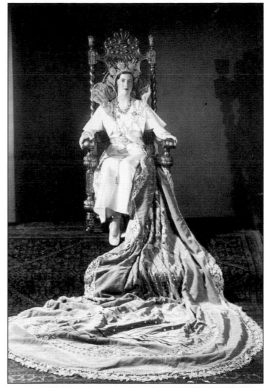

The horse-drawn carriage was the parade float of the day. The 1934 Cotton Carnival brochure describes the float as "an idea which especially appeals to the Carnival officers as a joyful way of spreading joy, who are going to secure a large truck, decorate it and climb aboard. With them they will bring their own little band—anything from a coronet to a jug band or a few harmonicas will do—and thus they will parade the streets. Think up some plan for yourself and your friends, and get your idea into motion, so that you will not be sitting on the side-lines when the fun begins."

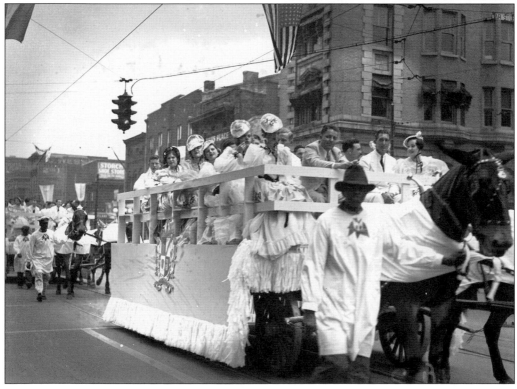

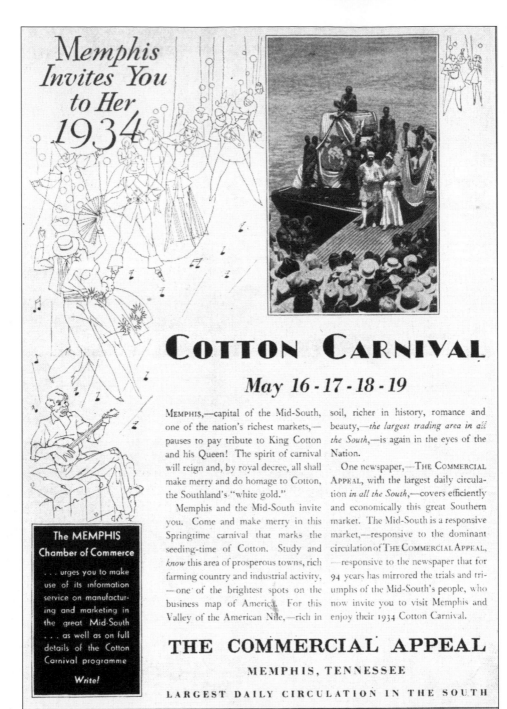

Memphis Invites You to Her 1934

COTTON CARNIVAL

May 16 · 17 · 18 · 19

MEMPHIS,—capital of the Mid-South, one of the nation's richest markets,—pauses to pay tribute to King Cotton and his Queen! The spirit of carnival will reign and, by royal decree, all shall make merry and do homage to Cotton, the Southland's "white gold."

Memphis and the Mid-South invite you. Come and make merry in this Springtime carnival that marks the seeding-time of Cotton. Study and *know* this area of prosperous towns, rich farming country and industrial activity, —one of the brightest spots on the business map of America. For this Valley of the American Nile,—rich in soil, richer in history, romance and beauty,—*the largest trading area in all the South*,—is again in the eyes of the Nation.

One newspaper,—THE COMMERCIAL APPEAL, with the largest daily circulation *in all the South*,—covers efficiently and economically this great Southern market. The Mid-South is a responsive market,—responsive to the dominant circulation of THE COMMERCIAL APPEAL, —responsive to the newspaper that for 94 years has mirrored the trials and triumphs of the Mid-South's people, who now invite you to visit Memphis and enjoy their 1934 Cotton Carnival.

The MEMPHIS Chamber of Commerce

. . . urges you to make use of its information service on manufacturing and marketing in the great Mid-South . . . as well as on full details of the Cotton Carnival programme

Write!

THE COMMERCIAL APPEAL

MEMPHIS, TENNESSEE

LARGEST DAILY CIRCULATION IN THE SOUTH

This advertisement, sponsored by the Memphis newspaper *The Commercial Appeal*, ran as a full-page advertisement in *Time* magazine on April 30, 1934. *Time*'s circulation at the time was 450,000. This illustrates well the scale of the carnival, as well as the projected national interest of the event. Col. James Hammond, publisher of *The Commercial Appeal*, believed that the Cotton Carnival was "the Gilded Mirror, which annually reflects the beauty, the romance, and the great resources of our Mid-South."

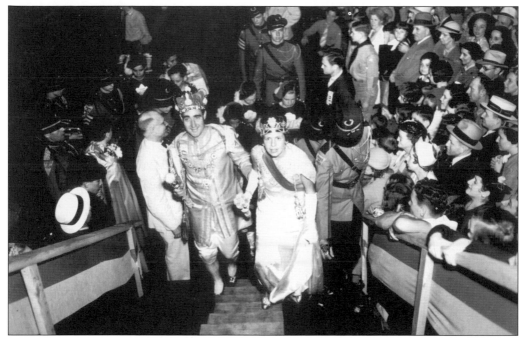

A swarm of spectators look on as the 1937 Cotton Carnival King and Queen, S. Richard Leatherman and Frances Chapman, climb a flight of stairs, seemingly to board a riverboat. The 1937 Memphis Cotton Carnival almost did not happen. Nine weeks before the its opening, a fire broke out, incinerating all of the floats and property of the Cotton Carnival Association. The initial committee vote was to postpone the event until the following year; the final vote was made to electrify the floats instead.

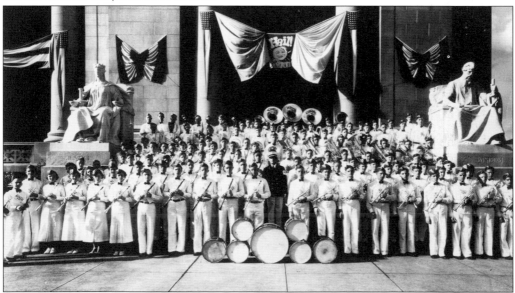

The "Official Band" from Memphis, Tennessee, poses rigidly in front of the Shelby County Courthouse on Adams Avenue in downtown Memphis. Directed by Prof. Charles F. Harrison, the band was one of over 30 bands from all over the Mid-South that participated in the festivities.

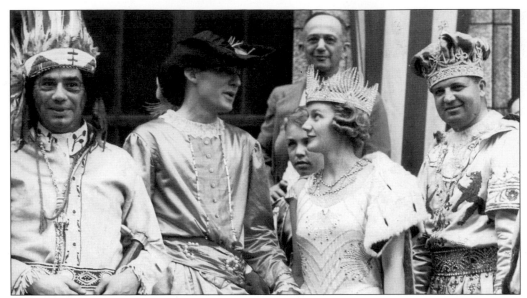

A Cotton Carnival princess is escorted by members of her royal court, including, puzzlingly, an Indian chief. The Cotton Carnival Association has come under criticism over the years for being sexist and elitist. Traditionally, the king is an older, connected gentleman with ties to whatever industry is being celebrated that year, while the queen is a young, unmarried woman who hails from one of the city's "better" families. Only in recent years have more events become open to the public, as opposed to being invitation only.

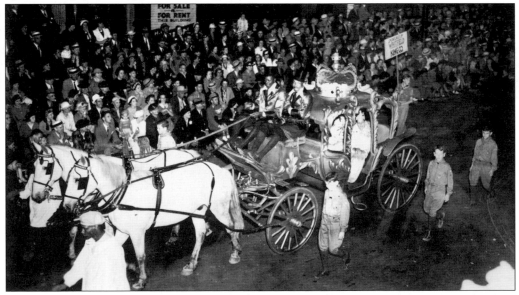

A Cinderella-esque carriage transports carnival royalty flocked by several footmen to the front and sides. In 1931, the president of the Memphis Cotton Exchange, Everett Cook, wrote, "Carnival is to promote business for everybody and should not be used by any one group. It is for all of the stores and all of the people, for all kinds of professions and businesses, for the city as a whole regardless of the size of the business, the social standing, wealth, prestige, family background or anything else that would tend to make anyone feel that he or she would not be invited to participate in Carnival."

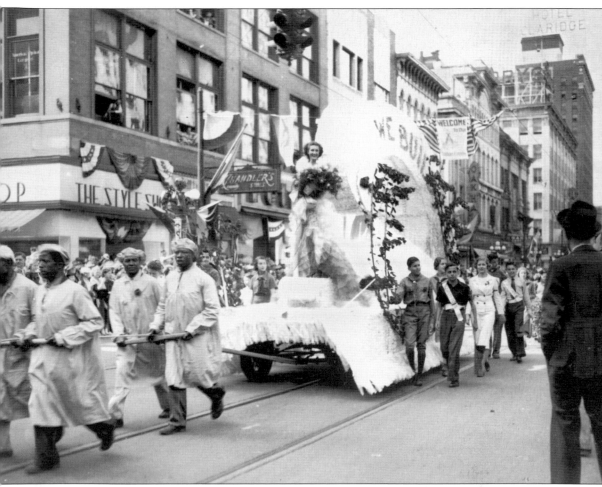

The first years of the Memphis Cotton Carnival were, unofficially, for whites only. There is a story regarding this thinly veiled racism; apparently, a Beale Street dentist, Dr. R.Q. Venson, attended the Cotton Carnival parade with his young nephew. What they saw was a scene akin to the picture above: black men were pulling the floats, while the white participants rode on top or walked alongside. When Dr. Venson asked his nephew what he thought of the parade, the boy answered simply that he did not like it, because "all the negroes were horses." This resonated with the doctor deeply, and shortly thereafter, Venson collaborated with other African-American Memphians to create their own carnival. They called it the Cottonmakers Jubilee. Dr. Venson also went on to form the Memphis Kemet Jubilee, one of the oldest Grand Krewes of Carnival.

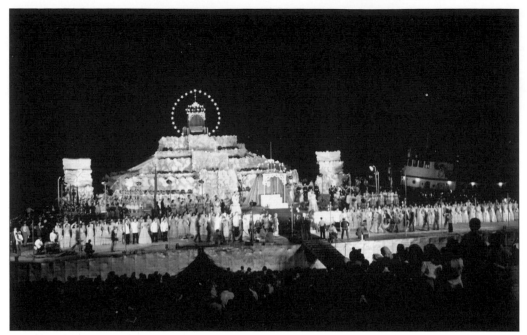

To open the Cotton Carnival, a magnificent display by the banks of the Mississippi was put on every year. Here, the king, queen, and royal court proceed from the Royal Barge to officially open the carnival. This was a stunning affair, complete with fireworks and entertainment.

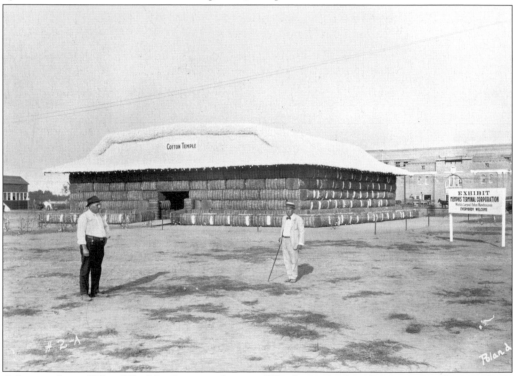

Advertised as "The World's Largest Cotton Warehouse," the Cotton Temple was built completely out of cotton and cotton bales.

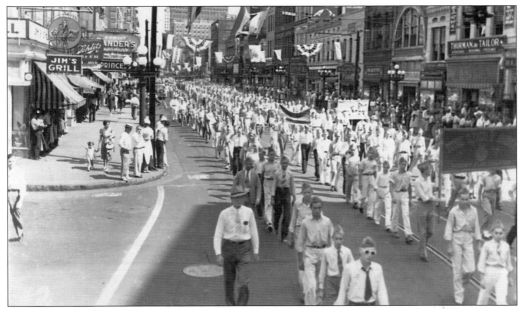

This snapshot from the 1940 Cotton Carnival shows the parade crossing the intersection of Main and historic Beale Street. Passing through the foreground of the picture are the Future Farmers of America, Hickory Flats Chapter. Only in its ninth year of existence, the Memphis Cotton Carnival had grown to an extraordinary size. It was touted on posters sent out nationwide as the "South's Greatest Party."

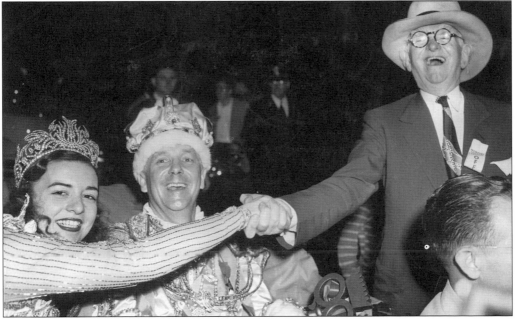

Former Memphis mayor E.H. Crump shakes the hand of 1940s-era royalty. "Boss" Crump was known as a shrewd politician; he knew how to oblige the interests of individuals and groups, and he single-handedly transformed Memphis into a well-functioning city after the turn of the century, all the while keeping taxes low. He demanded absolutism, and those who did not comply with his desires were quickly intimidated or run out of town.

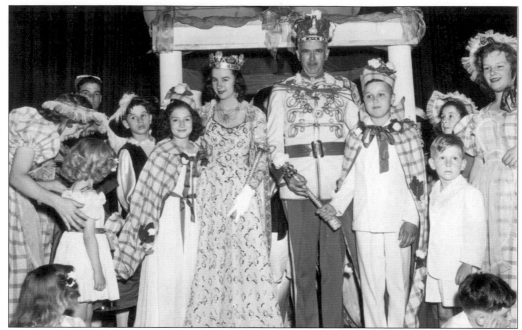

Among the pages, maids, and other kid royalty, the May 1946 Cotton Carnival King and Queen pose with their junior counterparts. From middle left are Junior Queen Elizabeth Ann Rodgers, Queen Phoebe Cook, King R. Vance Norfleet, and Junior King James Nelson Balton.

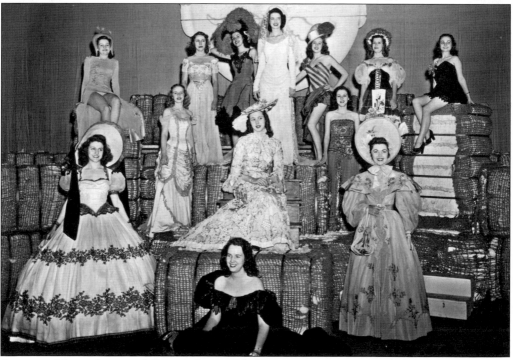

A group of festively attired Cotton Carnival ladies in waiting pose atop bales of cotton in May 1946. The ladies in waiting were female members of the royal court who were generally freshmen in college and had associations with carnival-sponsoring organizations.

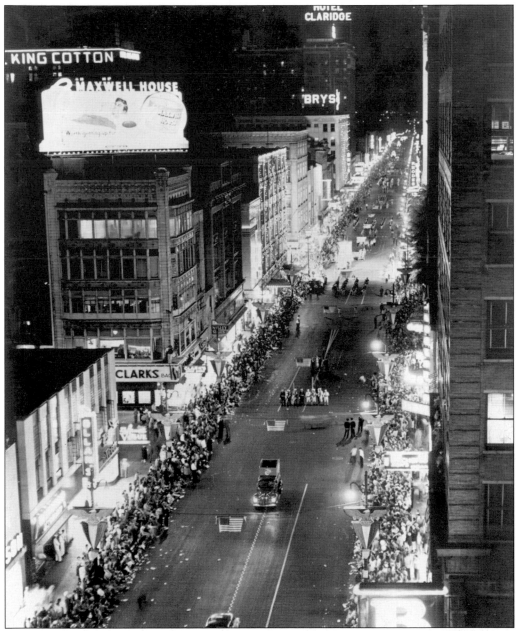

This is a bird's-eye view of the 1951 Cotton Carnival parade immediately after the royal barge docked on the opening night. This was generally the most spectacular part of the entire carnival week.

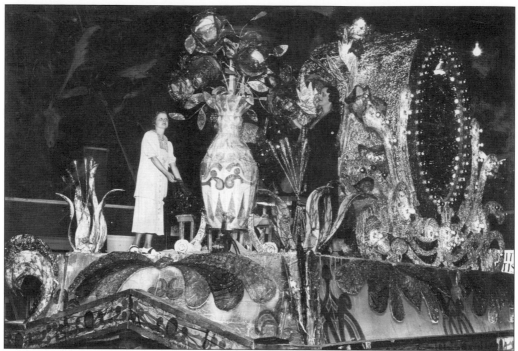

Great time and energy was spent on all of the floats in Cotton Carnival parades. Each year had a different theme and attention to detail was key. All floats were scrutinized to make sure that they were historically accurate. The float pictured above shows painstaking papier-mâché and lumber work, as well as detailed electrical work. Much planning was involved in the mechanics of the float. It had to be able to clear the trolley wires, and the wheels had to be constructed to avoid catching in car tracks. The float artists had a great deal to contend with during the carnival season.

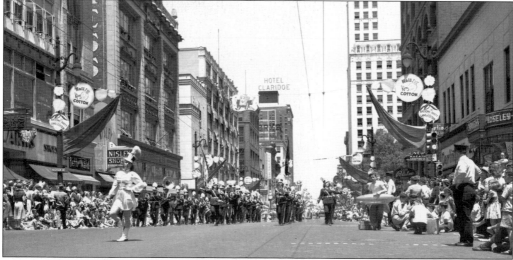

Throngs of people huddle along Main Street in downtown Memphis, as the Cotton Carnival parade crosses Madison Avenue. Signs along lampposts and buildings declare "Hail! King Cotton," while anthropomorphized cotton bales keep watch over the procession below. Memphis's downtown area was thriving and was at the apex of its prosperity.

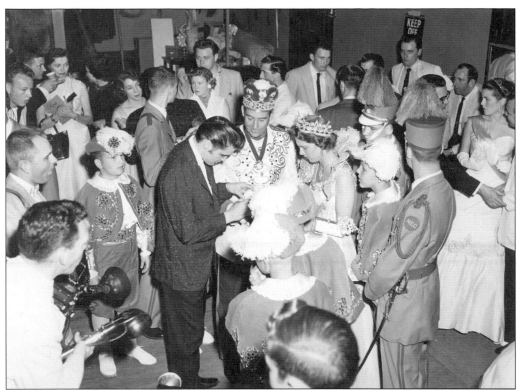

In May 1956, Elvis Presley performed during the Cotton Carnival for his adoring hometown fans. The performance drew a capacity crowd of 8,000 to the Ellis Auditorium in downtown Memphis. Ever the consummate Southern gentleman, Elvis signs autographs for the royal court of the 1956 Cotton Carnival.

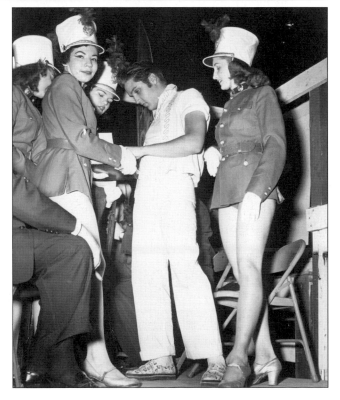

A group of very lucky majorettes get a chance to meet and greet Memphis's most prominent rising star, Elvis Presley. In 1956, Elvis was listed as one of the star performers on the Cotton Carnival; just two years earlier, a Memphis city directory listed him simply as "a truck driver on Alabama Street."

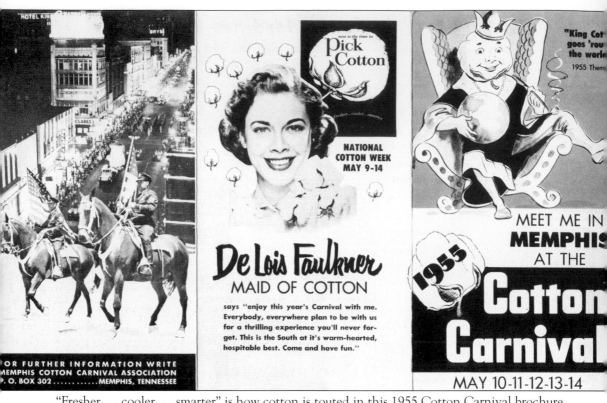

"Fresher. . . cooler. . . smarter" is how cotton is touted in this 1955 Cotton Carnival brochure. Featured prominently is the ubiquitous figure of King Cotton sitting on his throne, holding the world in his hands. The Cotton Carnival was an opportunity for Memphis to showcase itself as a vital Southern town. As the 1955 Maid of Cotton, DeLois Faulkner, says, "This is the South at its warm-hearted, hospitable best."

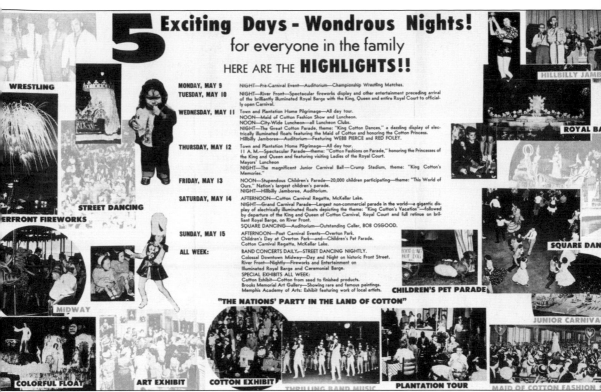

5 Exciting Days - Wondrous Nights!
for everyone in the family
HERE ARE THE HIGHLIGHTS!!

WRESTLING

HILLBILLY JAMB

ROYAL BA

RFRONT FIREWORKS

STREET DANCING

SQUARE DAN

MIDWAY

CHILDREN'S PET PARADE

JUNIOR CARNIVAL

MONDAY, MAY 9 NIGHT—Pre-Carnival Event—Auditorium—Championship Wrestling Matches.

TUESDAY, MAY 10 NIGHT—River Front—Spectacular fireworks display and other entertainment preceding arrival of the brilliantly illuminated Royal Barge with the King, Queen and entire Royal Court to officially open Carnival.

WEDNESDAY, MAY 11 Town and Plantation Home Pilgrimage—All day tour.
NOON—Maid of Cotton Fashion Show and Luncheon.
NOON—City-Wide Luncheon—all Luncheon Clubs.
NIGHT—The Great Cotton Parade, theme: "King Cotton Dances," a dazzling display of electrically illuminated floats featuring the Maid of Cotton and honoring the Cotton Princess.
Hillbilly Jamboree—Auditorium—Featuring WEBB PIERCE and RED FOLEY.

THURSDAY, MAY 12 Town and Plantation Home Pilgrimage—All day tour.
11 A.M.—Spectacular Parade—theme: "Cotton Fashions on Parade," honoring the Princesses of the King and Queen and featuring visiting Ladies of the Royal Court.
Mayors' Luncheon
NIGHT—The magnificent Junior Carnival Ball—Crump Stadium, theme: "King Cotton's Memories."

FRIDAY, MAY 13 NOON—Stupendous Children's Parade—20,000 children participating—theme: "This World of Ours," Nation's largest children's parade.
NIGHT—Hillbilly Jamboree, Auditorium.

SATURDAY, MAY 14 AFTERNOON—Cotton Carnival Regatta, McKellar Lake.
NIGHT—Grand Carnival Parade—Largest non-commercial parade in the world—a gigantic display of electrically illuminated floats depicting the theme: "King Cotton's Vacation"—followed by departure of the King and Queen of Cotton Carnival, Royal Court and full retinue on brilliant Royal Barge, on River Front.
SQUARE DANCING—Auditorium—Outstanding Caller, BOB OSGOOD.

SUNDAY, MAY 15 AFTERNOON—Post Carnival Events—Overton Park.
Children's Day at Overton Park—and—Children's Pet Parade.
Cotton Carnival Regatta, McKellar Lake.

ALL WEEK: BAND CONCERTS DAILY—STREET DANCING NIGHTLY.
Colossal Downtown Midway—Day and Night on historic Front Street.
River Front—Nightly—Fireworks and Entertainment on Illuminated Royal Barge and Ceremonial Barge.
SPECIAL EXHIBITS ALL WEEK:
Cotton Exhibit—Cotton from seed to finished products.
Brooks Memorial Art Gallery—Showing rare and famous paintings.
Memphis Academy of Arts: Exhibit featuring work of local artists.

"THE NATIONS' PARTY IN THE LAND OF COTTON"

COLORFUL FLOAT

ART EXHIBIT

COTTON EXHIBIT

THRILLING BAND MUSIC

PLANTATION TOUR

MAID OF COTTON FASHION S

This segment of the 1955 Cotton Carnival brochure outlines the massive amount of activities that went on during carnival week. It is clear that there was more to the carnival than just the parade and the royal court. Everything from pet parades, to plantation tours, to championship wrestling drew substantial crowds for five days in May. The carnival had already garnered national attention; it had been featured in *Life* magazine over 10 years earlier.

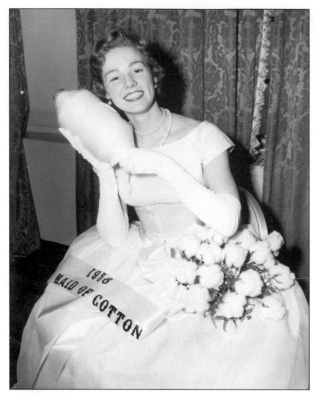

Miss Jean Carter of Atlanta, Georgia, was named "The Maid of Cotton" for 1958. Here she poses, fittingly, with cotton thread. The Maid of Cotton title originated with the Memphis Cotton Carnival but was taken over in 1940 by the National Cotton Council (NCC). The NCC transformed the Maid of Cotton selection into a promotional and merchandising program. The title was chosen annually until 1993.

A happy meeting between royalty on Beale Street is captured in this shot. The Cotton Carnival King shakes the hand of the Cottonmakers Jubilee King. The Cottonmakers Jubilee, an event celebrating African-American achievements in the cotton industry, merged with the Cotton Carnival (now called Carnival Memphis) in 1982.

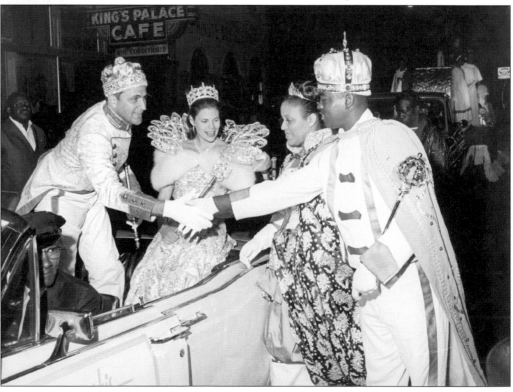

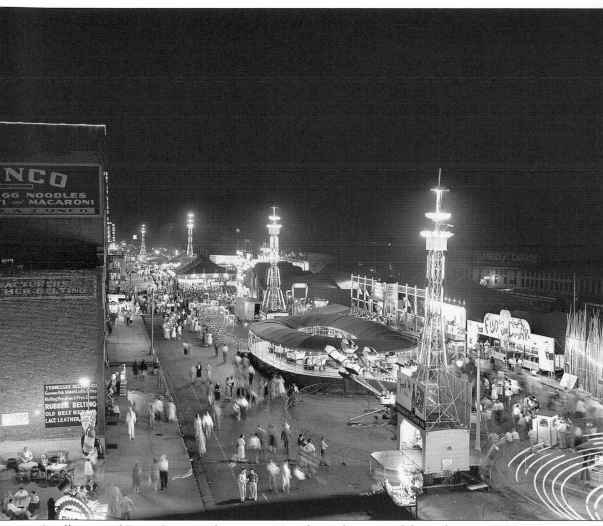

An illuminated Front Street in downtown Memphis is the scene of the midway at a 1950s-era Cotton Carnival. Cotton Carnival eventually moved to the fairgrounds and included the first several Memphis Music Festivals.

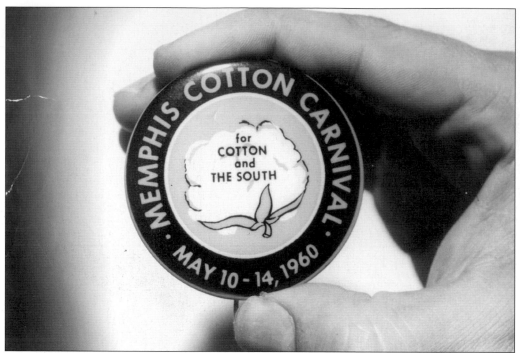

This is a souvenir button from the 1960 Cotton Carnival. Although it reads, "for Cotton and the South," by this time, Memphis's dependence on the crop had begun to wane. Despite that fact, the spirit of the carnival has remained the same over the years. It is a celebration of Southern pride and, moreover, the roots of Memphis's existence.

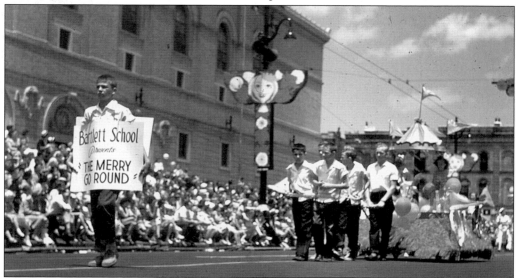

Children from the Bartlett School in Memphis march along in a 1960s-era Cotton Carnival parade. "The Merry Go Round," ridden by two girls, is pulled ably by six strapping young men. School children from all over the city were asked to participate in the carnival parade. Generally, students would choose one or two children from each grade to represent their school. Very strict guidelines had to be followed, however: each child was required to be clothed in cotton from head to toe, excluding shoes.

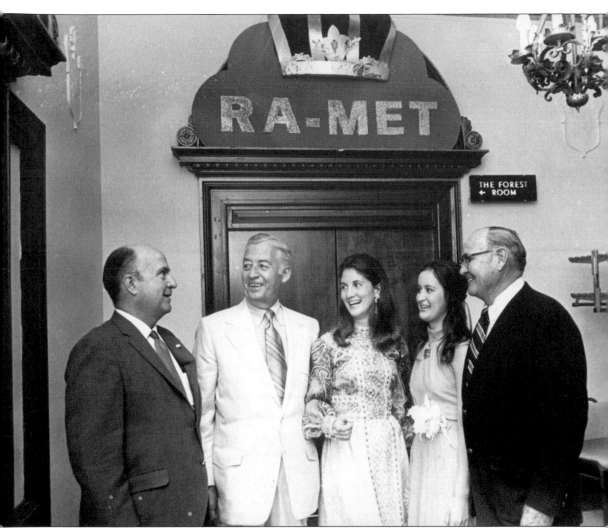

The Grand Krewe of RaMet has been a part of the carnival since 1938. This picture is taken from a May 1972 RaMet gala. Pictured, from left to right, are Charles Taylor, Walter May, Sophie Coors, Sandra Hill, and William McDonald. RaMet is one of the 12 mysterious krewes of the carnival; the others are Osiris, Sphinx, Memphi (the oldest, dating back to 1872), Phoenix, Ennead, AANI, Ptolemy, Ptah, Kemet Jubilee, Queen Bees, and the Boll Weevils. Today's RaMet society holds an annual charity golf outing that benefits a different children's charity every year.

The Al Chymia Shriners of Memphis are a permanent fixture of Memphis entertainment, including the annual Al Chymia Shrine Circus and, of course, the Cotton Carnival. Here, the familiar red fez dot the edges of Main Street accompanied by multi-colored minicars; the Shriners have always been known for their light-hearted approach to family entertainment. In addition, the Shriners sponsor the Shriners Hospitals for Children.

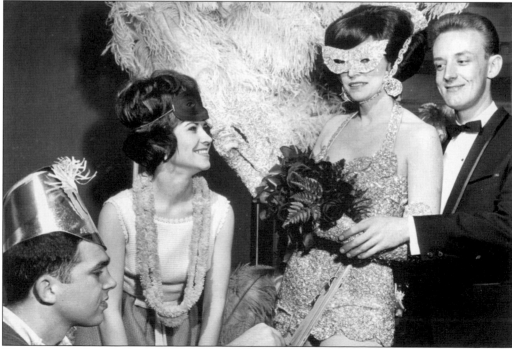

The spirit of New Orleans's Mardi Gras celebration could most definitely be felt in Cotton Carnival revelries. Pictured, from left to right, are Clay Buchanan, Judy Kraft, Mrs. Orley Nettles, and Eddie McLeod.

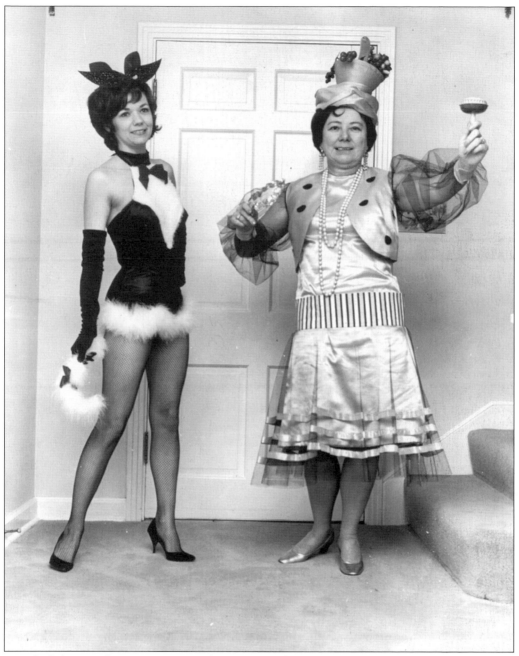

Brenda Schutt and Mrs. Lewis Wood Jr. pose at the Pussycat Society Gala. Generations of Memphians have served the community, kept traditions alive, and cemented friendships through the carnival societies.

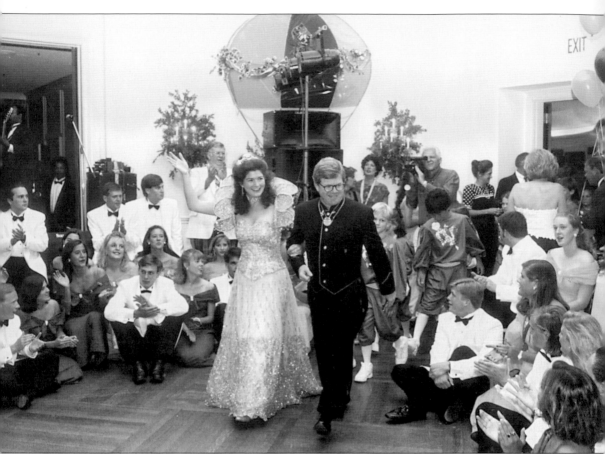

Baylor Ledbetter, 1993 Carnival Memphis Queen, and King Charles Brindell Jr. make a grand entrance into one of the many parties and social events during the annual May festival. The 1993 motto was "Remember the Past, Enjoy the Present and Plan for the Future." The carnival has been called the "Party with a Purpose" and for good reason: court members and other participants spend a great deal of time performing community outreach and visiting institutions such as St. Jude Children's Research Hospital, Memphis's premier cancer research facility. Although the carnival's focus has changed from strictly cotton, it remains a grand celebration of Memphis industry and society.

Five

FIELD TO FABRIC

Cotton is the number one cash-generating crop in the United States, making the cotton industry one of the most vital in the land. Cotton pulls in over $60 billion dollars a year and employs more than 340,000 people. Although cotton culture and manufacturing has changed dramatically in this century alone, its impact on our economy reaches far. Fourteen states account for the largest portion of cotton farming in the country: Alabama, Arizona, Arkansas, California, Georgia, Louisiana, Mississippi, Missouri, North Carolina, Oklahoma, South Carolina, Tennessee, Texas, and Virginia. These states form the "Cotton Belt" and are similar in that they all have plenty of sunshine, fertile soil, and plenty of water year-round. Planting begins anywhere from February to June, depending on the area of cultivation.

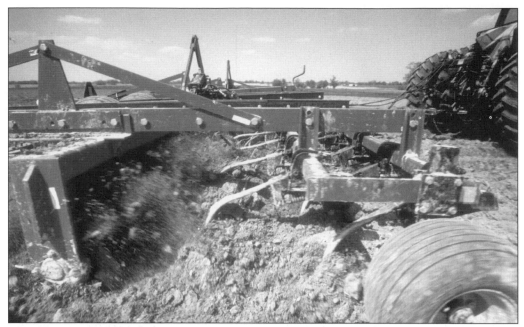

The first step of all cotton cultivation is tilling the land. Even before tilling, farmers prepare the land by clearing stalks from the previous crop to cut down on pest issues. This process compacts the soil and protects it from erosion. At the start of the growing season, the land is tilled to loosen the soil. This creates optimal conditions for the cotton plant to take root and have enough support throughout the growth process. Next, the seedbed must be prepared by listing, or molding the land into ridges and furrow. This ensures that the soil can be warmed by the sun quickly and aids in irrigation.

A cotton worker loads a mechanical planter full of cottonseed. The ideal soil temperature for planting cottonseed is 65 degrees. When this temperature is reached, the planter will place the seed in the soil, generally one to two inches deep. The mechanical planters are able to cover as many as 12 rows at a time, greatly expediting the planting process.

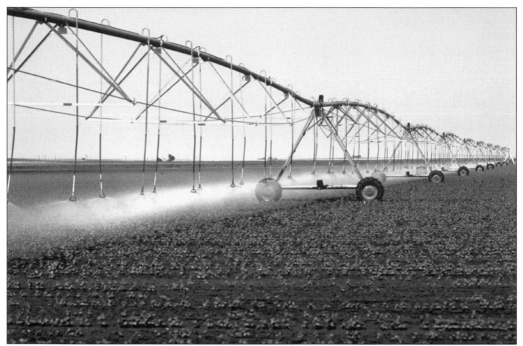

Growing cotton plants must be protected from pests and weeds that threaten to consume the plants or deplete the soil of vital nutrients. These large machines apply herbicides to the plant to control weed growth. After the cotton begins to sprout, weed removal must be done very carefully by hand or by cultivators to ensure that no damage is done to the fledgling plant.

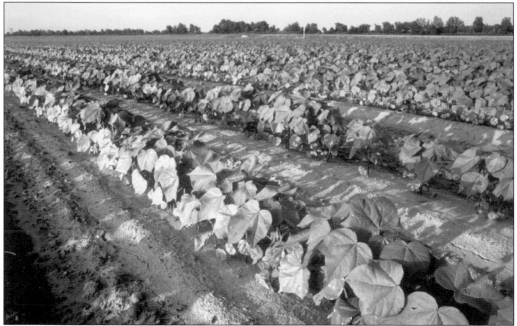

Rows and rows of lush green foliage mark the second to fourth week of cotton development. The smaller cotyledons are shed and overtaken by what are called "true leaves." These true leaves are responsible for feeding the cotton plant for the duration of growth.

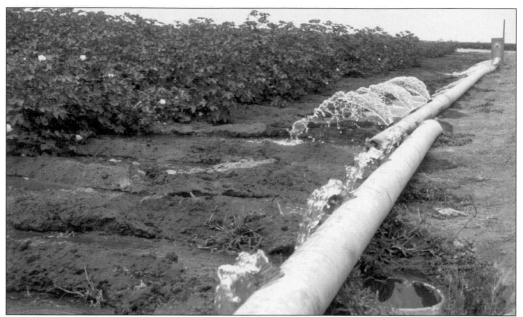

Generally, cotton requires more water than that provided by rainfall, especially in the western states. Different methods of irrigation are used by cotton farmers to ensure that their crops are successful. With furrow irrigation, pictured here, water is simply run down the seedbed furrows. Other methods are sprinkler irrigation, which uses pressurized water dispersed in the field using devices similar to lawn sprinklers, and drip tape irrigation, which uses a tube running under the cotton crop to distribute water into the soil.

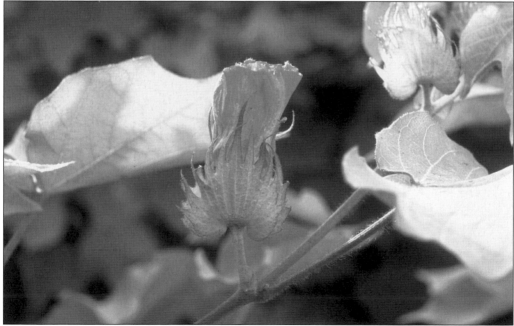

At five to seven weeks, small flower buds develop on the cotton plants. These buds are covered by a leaf-like shell and are called "squares." The square develops into a full flower, and as it pollinates, it changes from a creamy white color to a pinkish red.

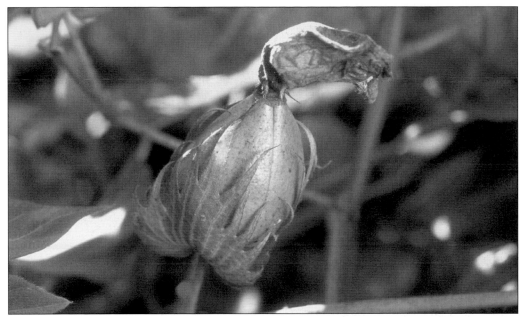

A small, undeveloped cotton boll emerges from underneath a withering cotton blossom. This green pod contains 32 seeds that will grow into cotton fibers. Interestingly, during this phase of development, the cotton boll is considered a fruit because of its seed content. For approximately the next eight weeks, the cotton fibers will grow within the boll, enlarging it to the size of a small fig.

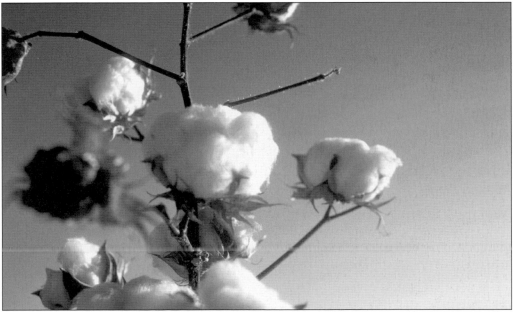

The cotton fibers have fully matured, aided by cellulose within the boll. The boll has naturally split along the carpels, or boll segments, to expose the cotton within. The dried carpels, or burs, hold the cotton fibers in place until the crop is ready to be harvested, generally at week 25. Each plant will yield about 100 bolls of cotton, with each boll containing about 500,000 cotton fibers.

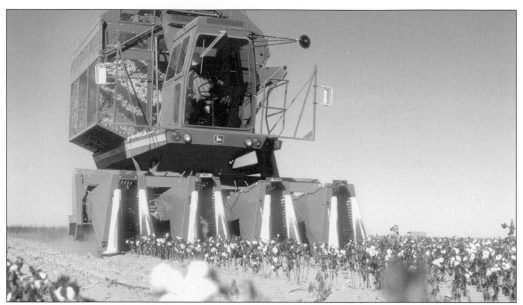

The mechanical cotton picker lumbers through the field. The plants are led through the picker head, where the cotton is plucked from the burs by spindles and then sucked through a suction duct into a collection basket. These spindle-type cotton pickers are the most widely used method of harvesting. It is essential that the cotton crop be harvested before any weather damage can be done to the crop. With today's mechanized cotton picking, six to eight rows can be covered at a time, and 190,000 pounds of seed cotton can be collected in a day.

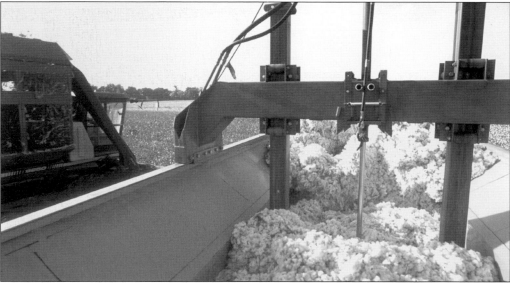

All the cotton collected in the field goes directly to a module builder. These module builders take the cotton from the picker's basket and press it into tightly packed blocks, or modules. Module builders are a fairly recent invention, introduced in 1972. Before, cotton was packed into trailers and taken directly to the ginning facility, often at a much faster rate than the cotton was actually being processed. This caused major backups and generally meant that cotton had to stop being harvested in order for the gin to catch up. A single cotton module can weigh up to 25,000 pounds.

With module builders, these cotton modules can be stored in the field and taken to the gin at a later date, thus eliminating any delays in the harvest process. These blocks of cotton will be loaded onto a truck and taken to the gin as soon as room becomes available.

The cotton that has been brought into the gin is sucked up by vacuums that carry the fibers to a dryer. Drying the cotton reduces moisture and enhances the overall quality of the product. This is the first step in the ginning process.

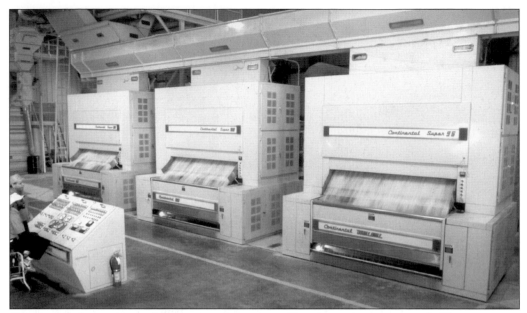

Ginning is the process of separating the cotton fiber from the cottonseed. There are two different ginning methods. For cotton with short fiber length, a saw gin grabs the fibers and pulls them through thin slots, eliminating seeds in the process. If the cotton has longer fibers, the seed is pulled from the fiber in a roller gin. This gin uses roughly textured rollers that pull the fiber between rotating bars too narrow for the seed to pass through.

After ginning, the deseeded fiber is pressed into cotton bales. The standard bale is 55 inches tall, 28 inches wide, 21 inches thick, and approximately 500 pounds. One bale can make 325 pairs of denim jeans, 609 terry bath towels, 1,217 men's t-shirts, 3,085 diapers, 6,436 women's knit briefs, or 313,600 hundred-dollar bills! Men's and boys' clothing dominates the apparel demand for cotton. Cotton is the number one fiber choice for towels and washcloths and is used in 60 percent of all sheets and pillowcases.

Cotton bales are packaged by eight steel straps and, after being sampled for classing, are wrapped for protection. They are then shipped around the world to textile mills and storage yards. Textile mills in the United States process more than seven billion bales of cotton annually. Of that, 57 percent is converted into clothing, and over a third is used in home furnishing. The rest is turned into industrial products. Cotton has gained retail and home furnishings market share in the last 30 years, rising from a historical low of 34 percent in the 1970s to over 60 percent today.

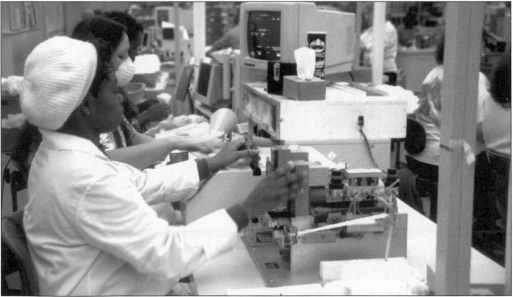

In today's cotton industry, cotton classing is done by precision instruments that make cotton classification data available immediately to producers. The mechanization of cotton classing has moved the industry beyond reliance on human instincts for classification, providing the best quality information possible. The USDA classes over two million bales a week during the peak of the season.

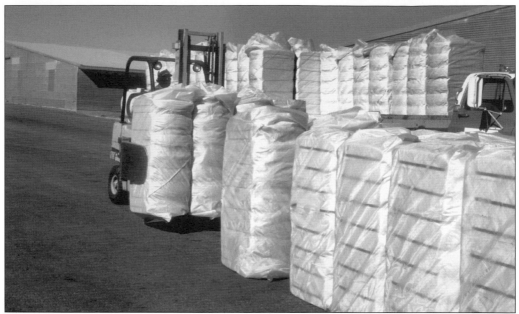

After the cotton has been prepared for shipment, the marketing process begins. Cotton is priced according to the quality of the fiber. A good deal of selling and reselling takes place before it reaches the textile mill. Growers sell to local merchants, who store the cotton for long periods of time before reselling. This system works since cotton is a non-perishable crop that can be stored in government-approved warehouses and used as collateral when taking out loans.

Cottonseed is used in a variety of practical and profitable ways. For every 100 pounds of cotton fiber, around 162 pounds of cottonseed are produced. Of the total seed crop, only five percent is reserved for replanting. Cottonseed oil is derived from the kernel of the seed by presses or solvent extraction. The remainder of the kernel is turned into the meal. Known for its high protein content, this meal is used for all categories of livestock and poultry.